Locally made gown

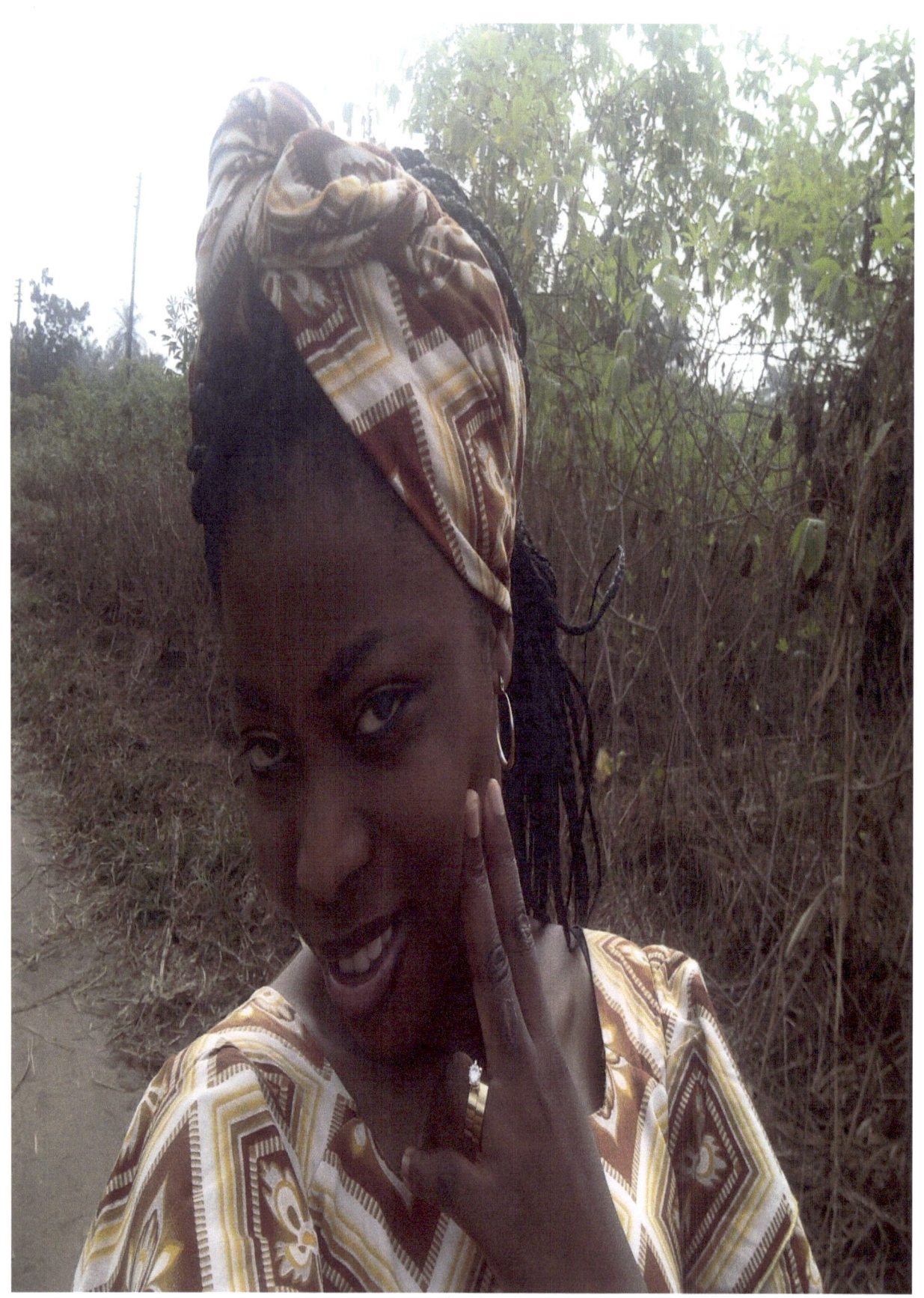
Braided hair

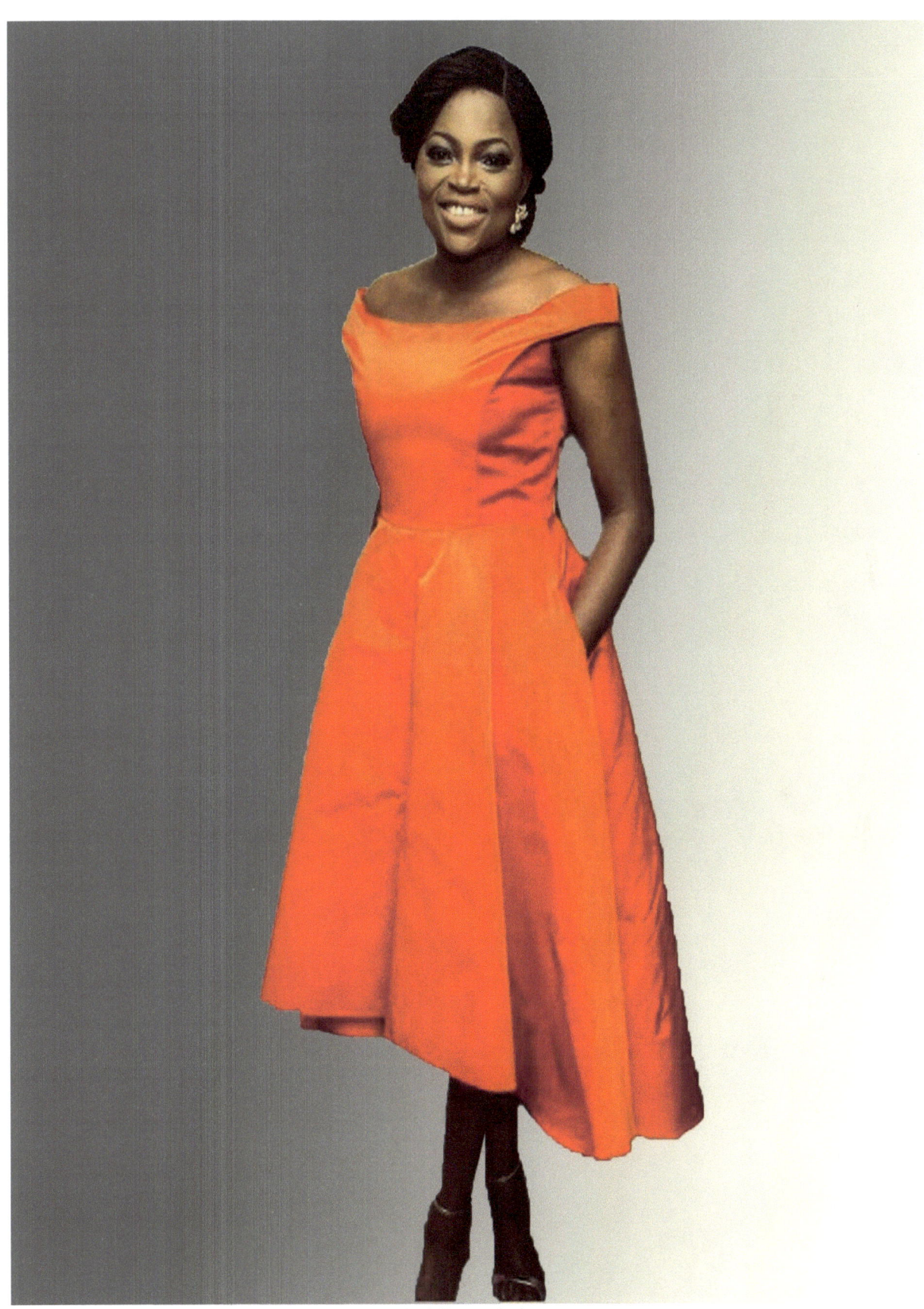
A locally made hair

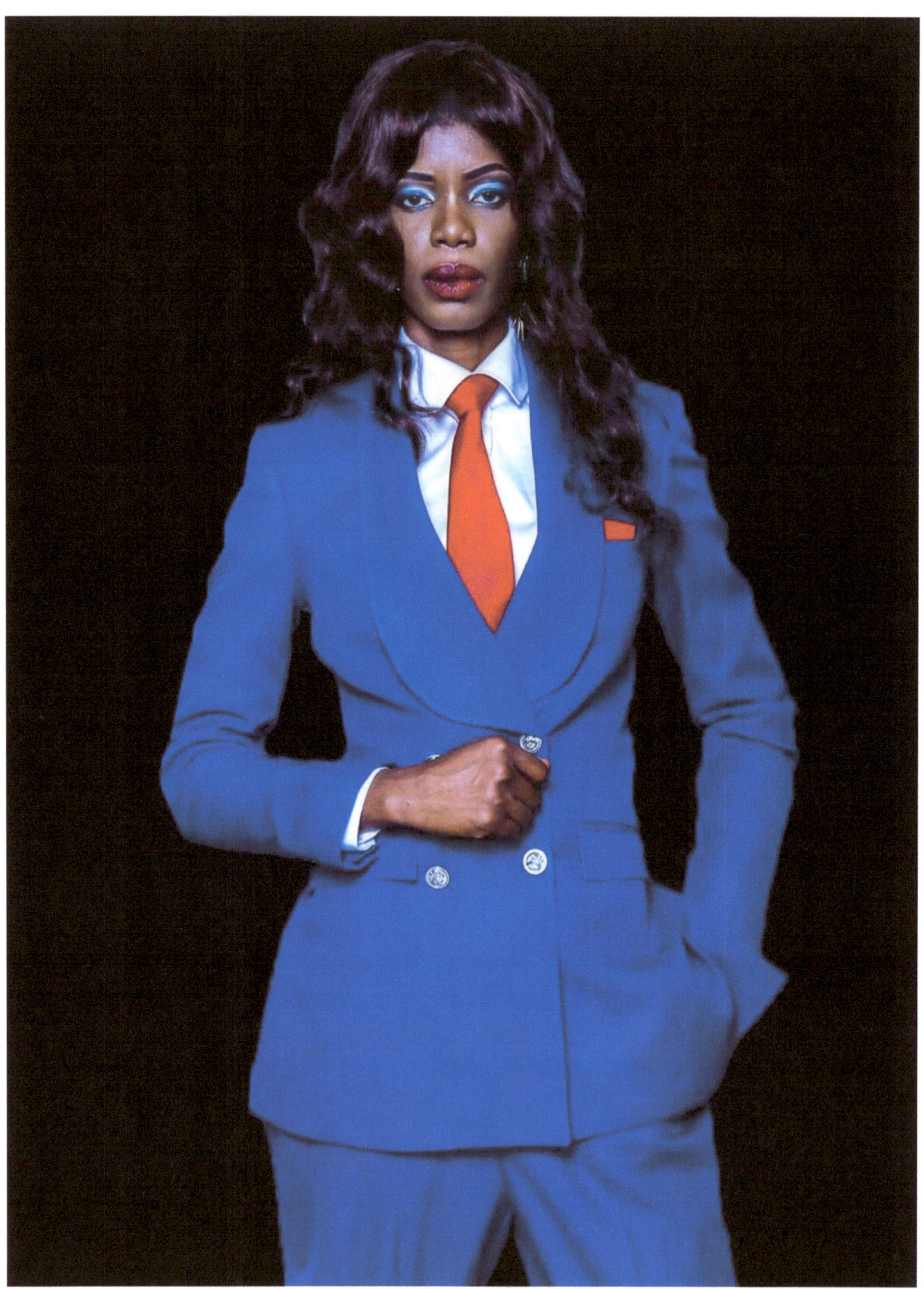
A nigerian made trouser suit

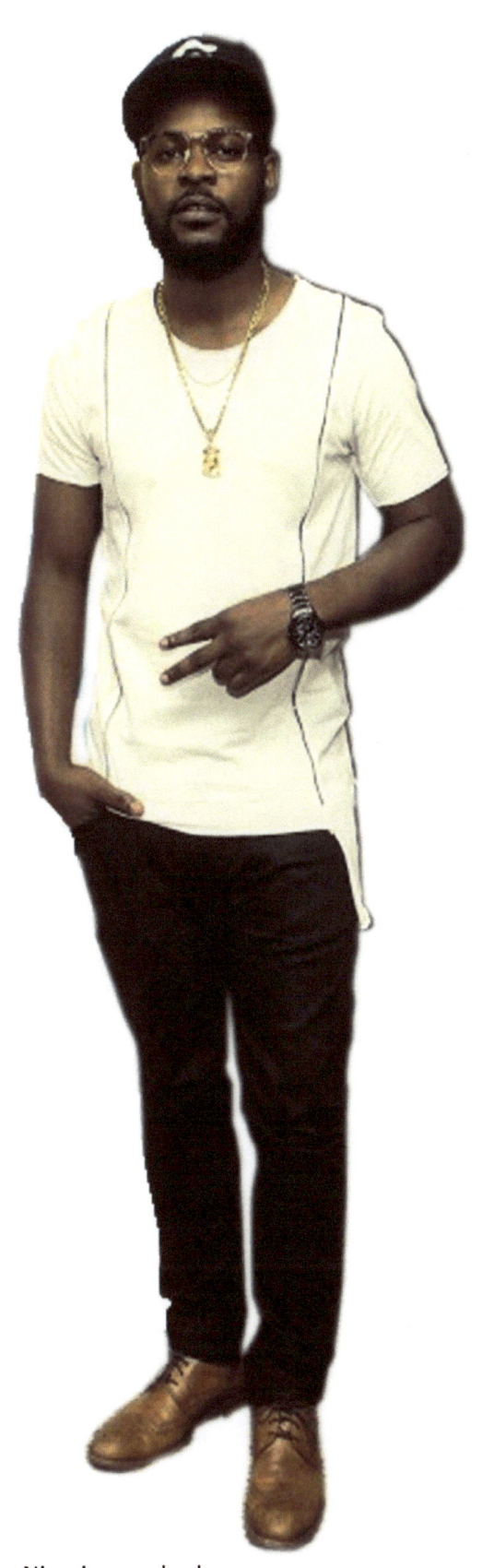
Nigerian made shoes

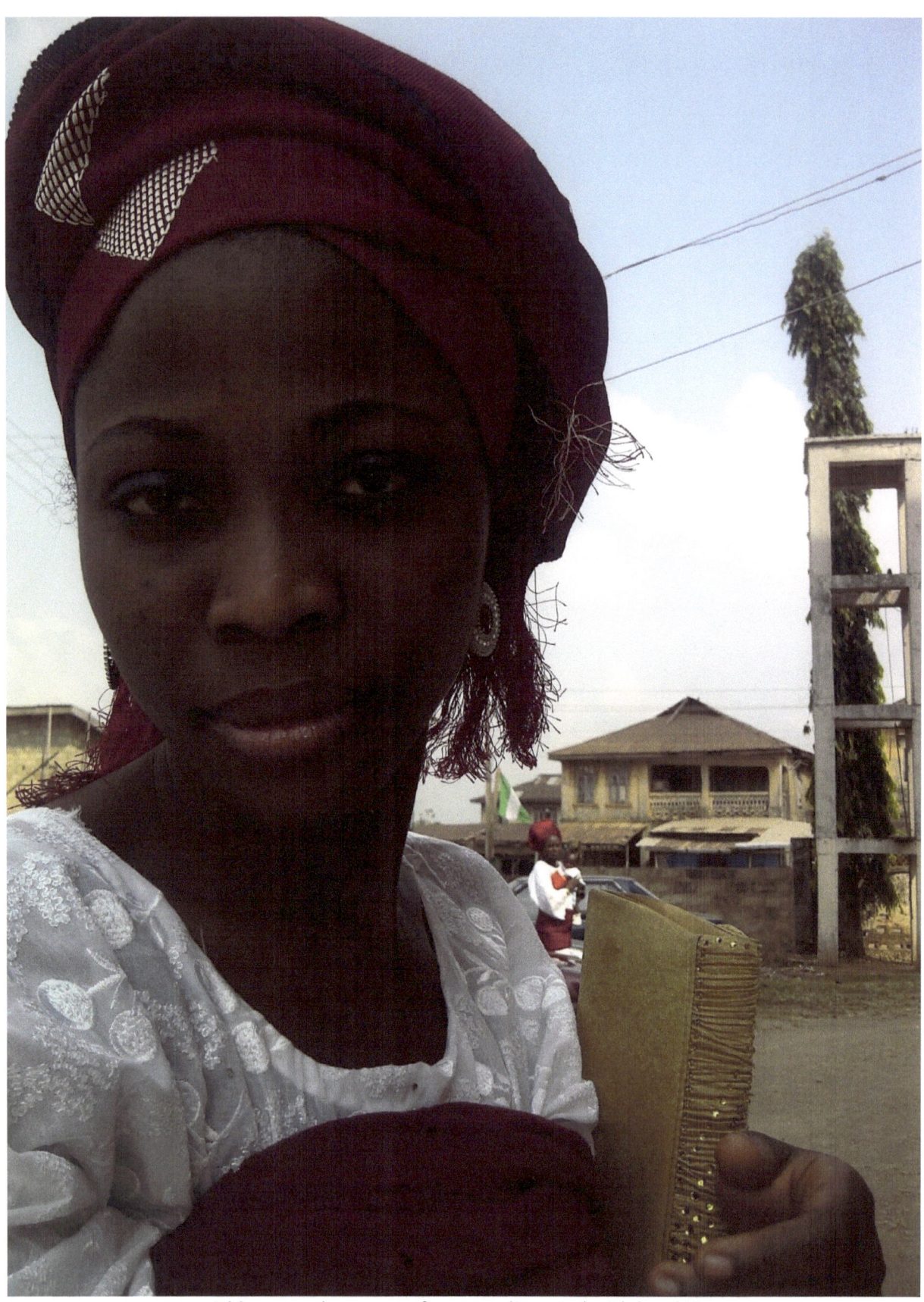

A blowse and wrapper often complimented with head ties

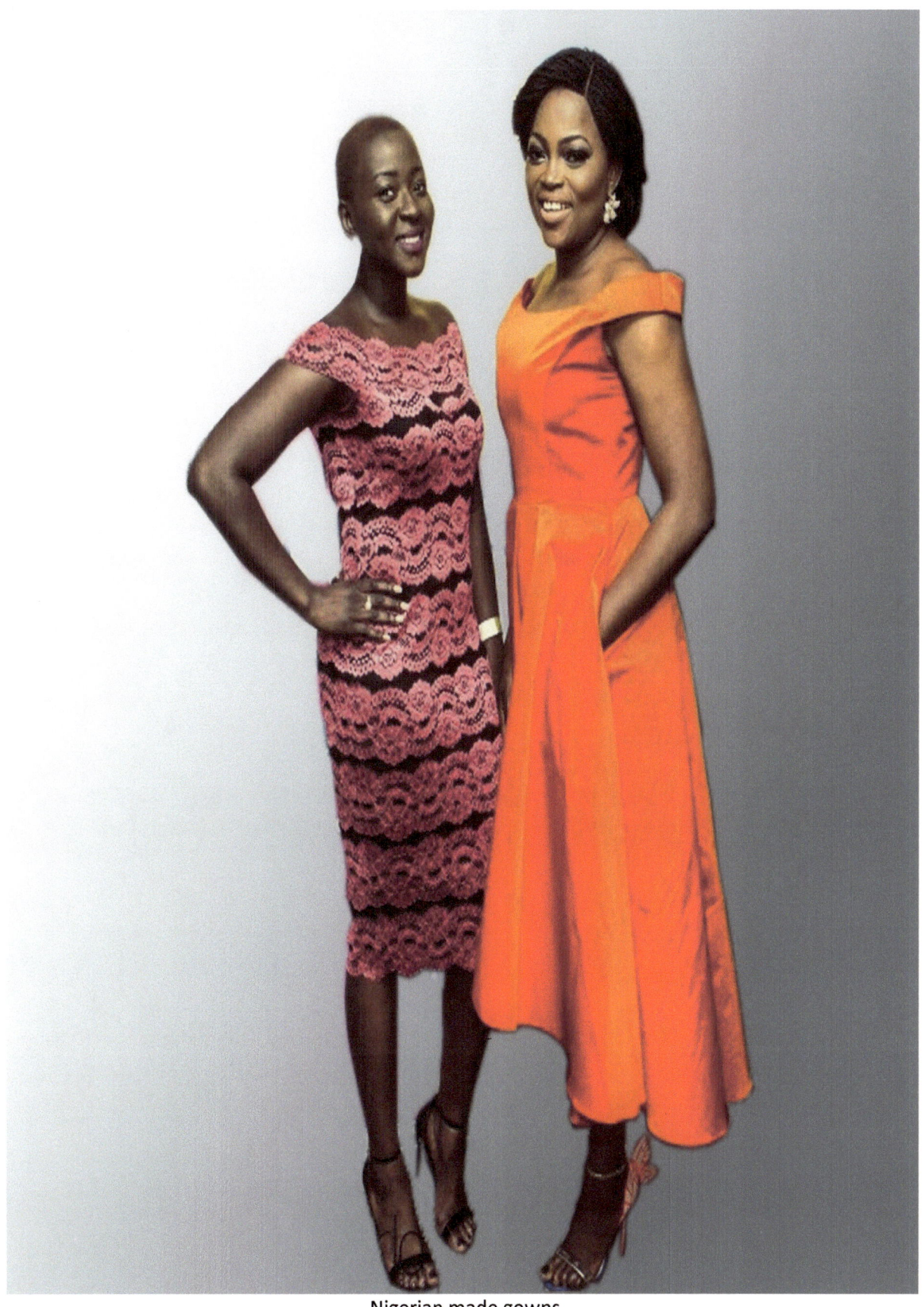

Nigerian made gowns

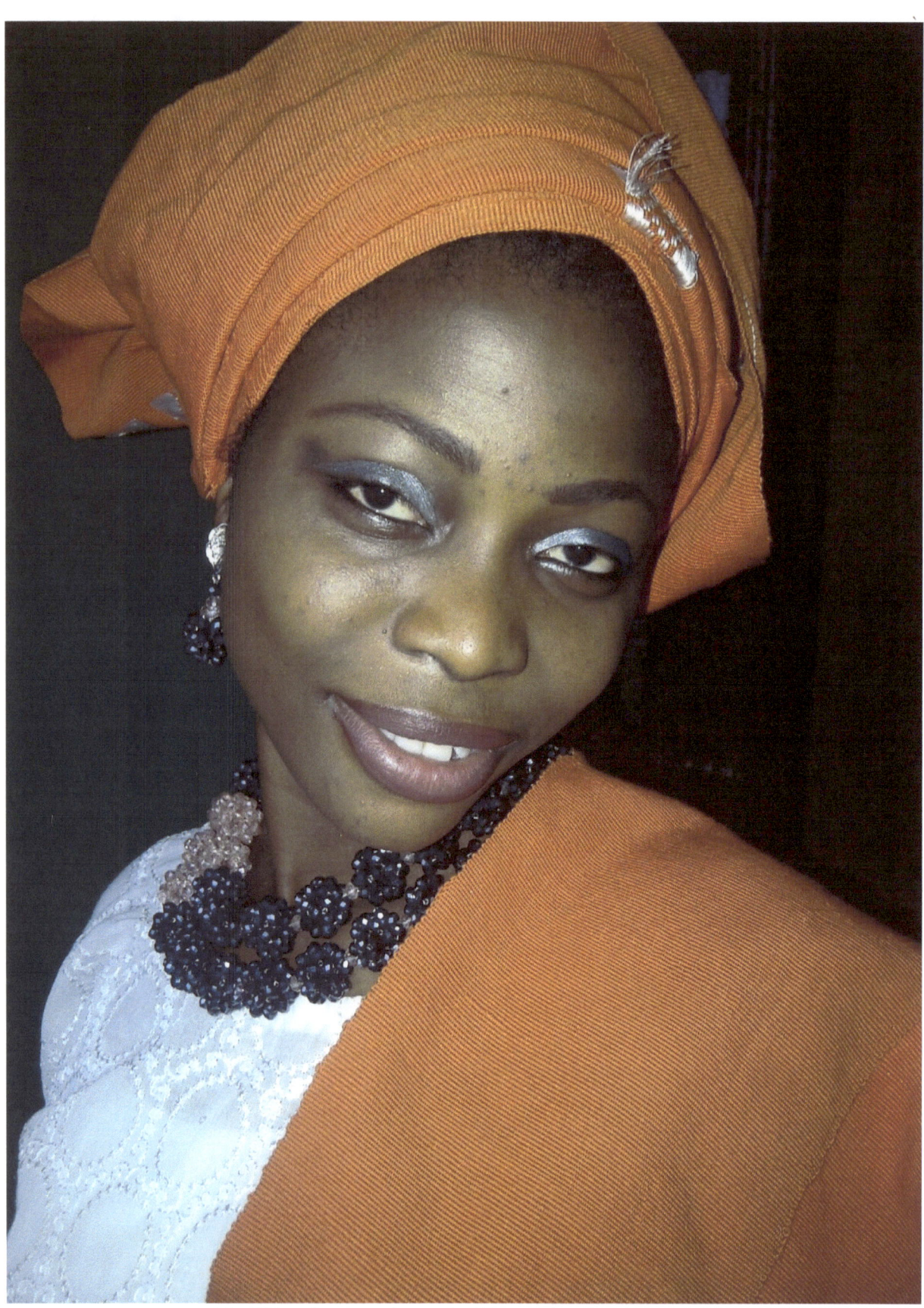

A traditional wear enhanced with neck beads and head tie

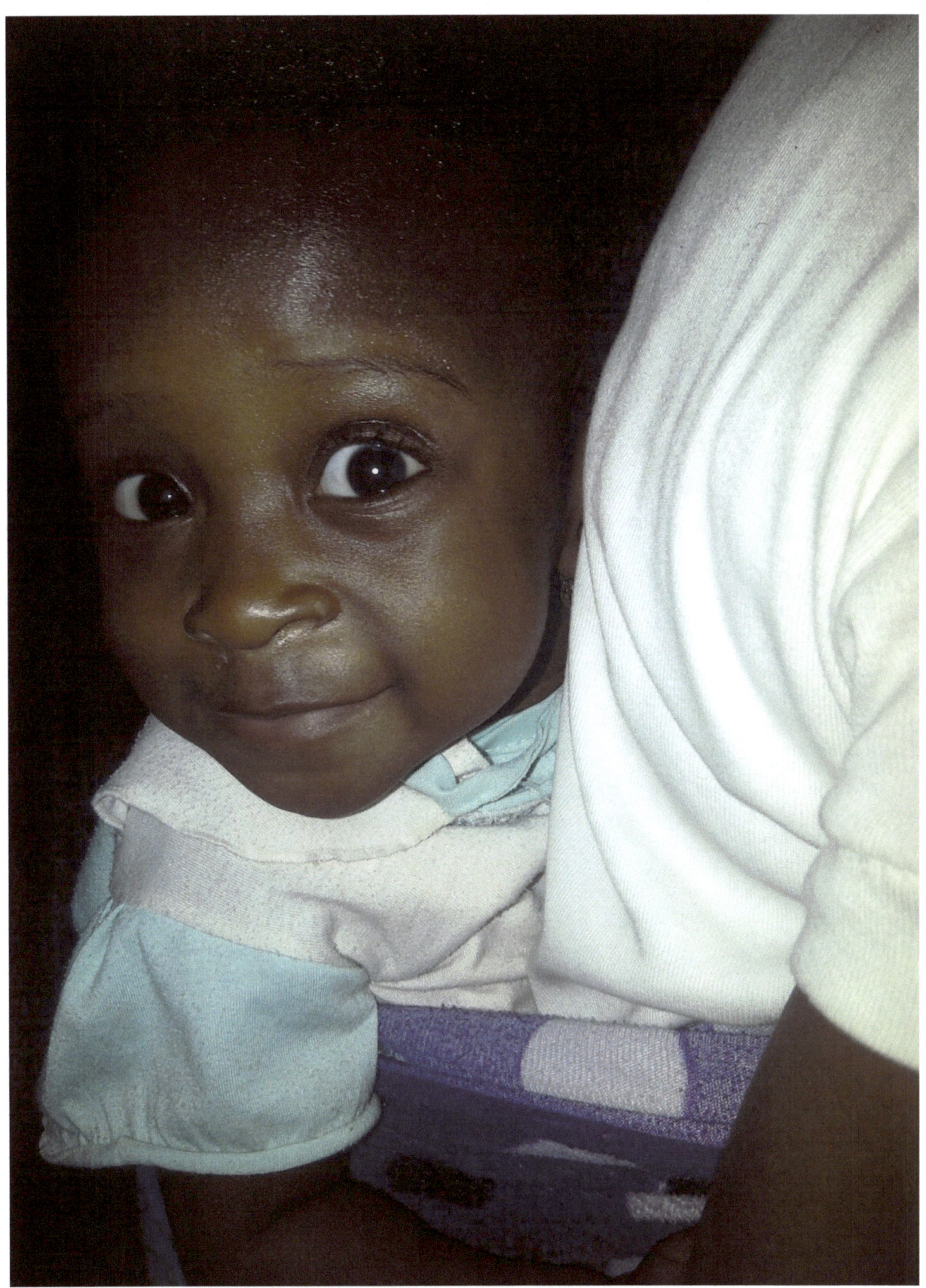

Traditional and convectional way of carrying babies on the back

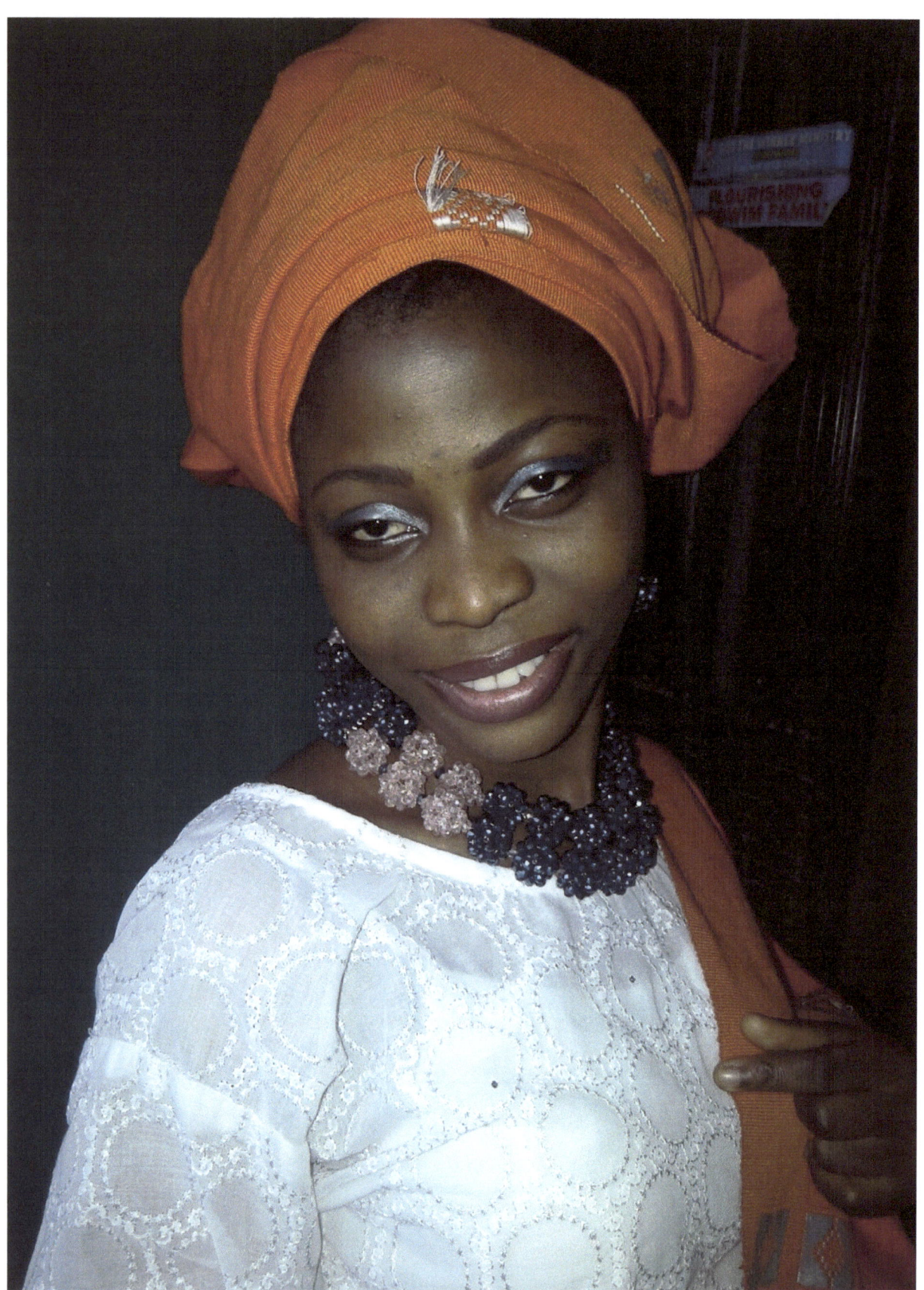

Another view of an African woman

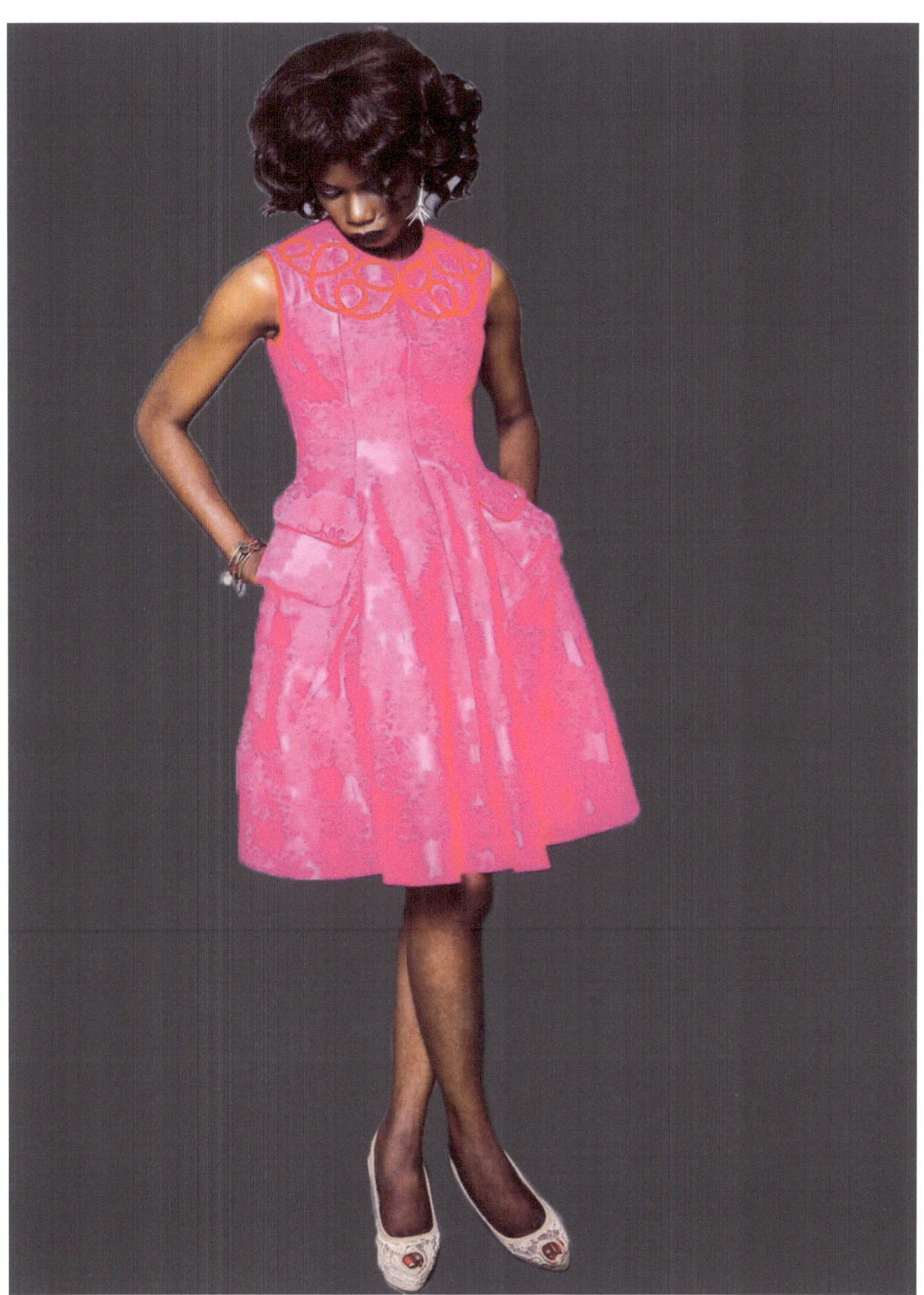

A well fitted gown made locally

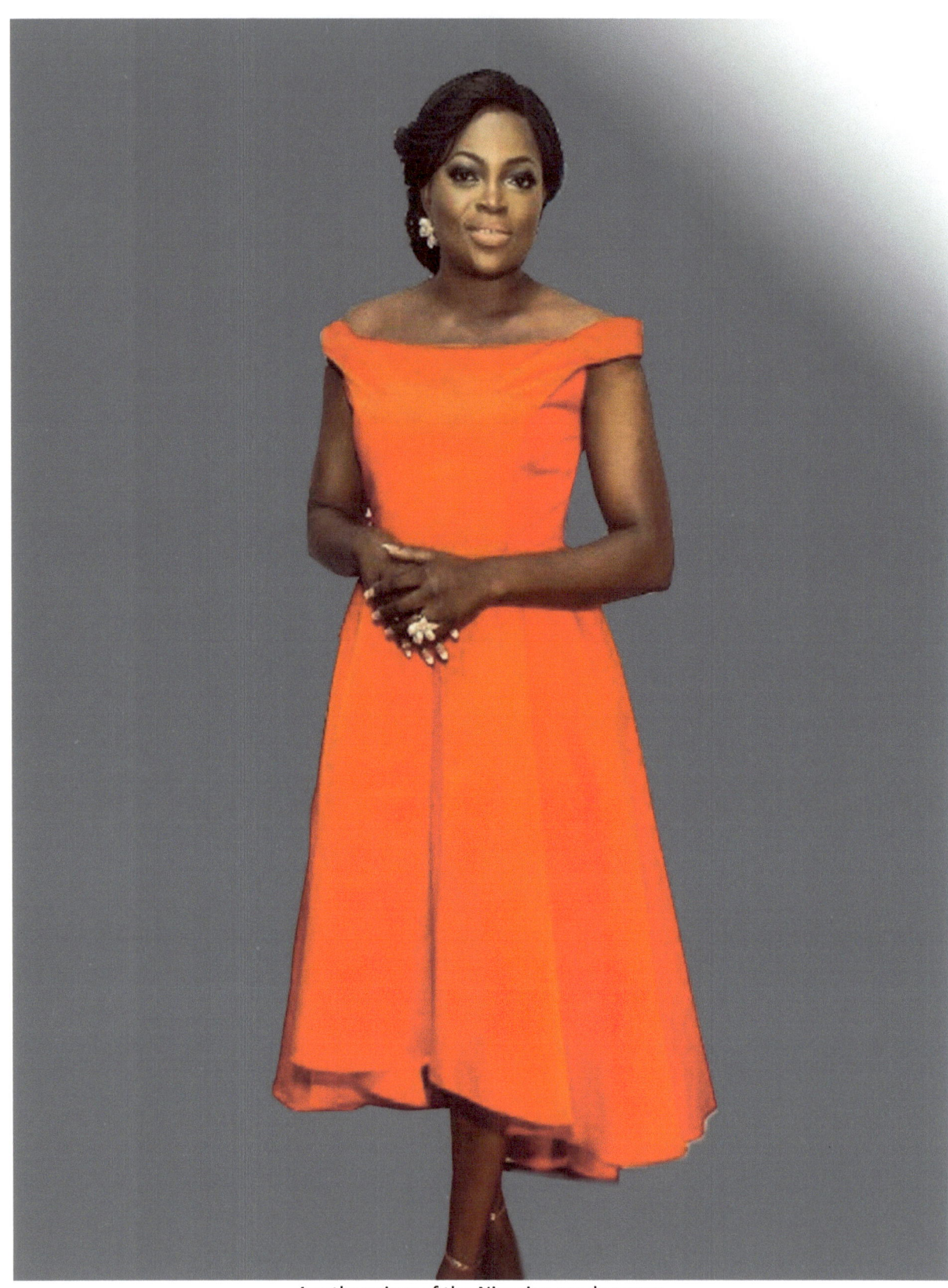
Another view of the Nigerian made gown

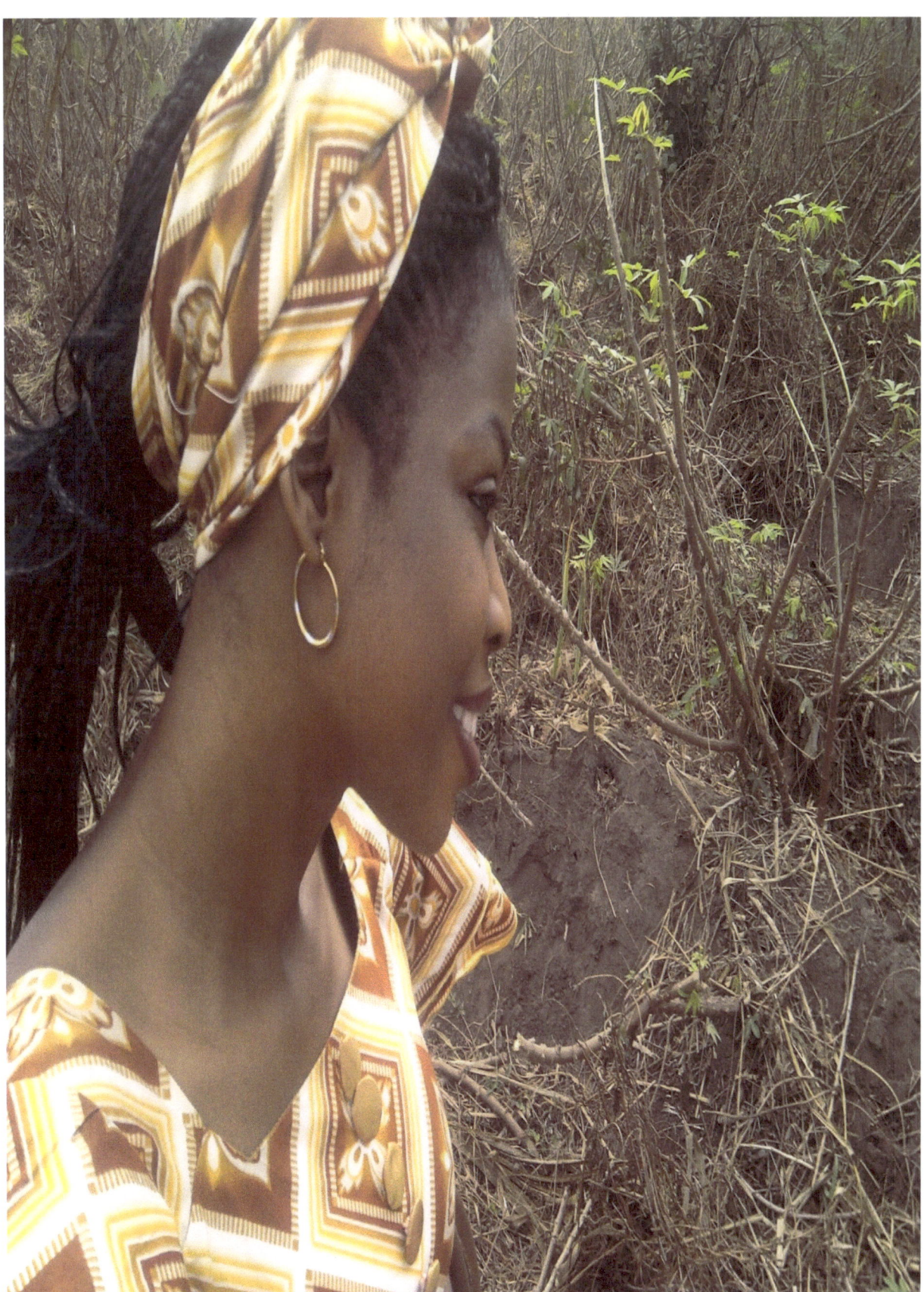

A side view of a braided hair

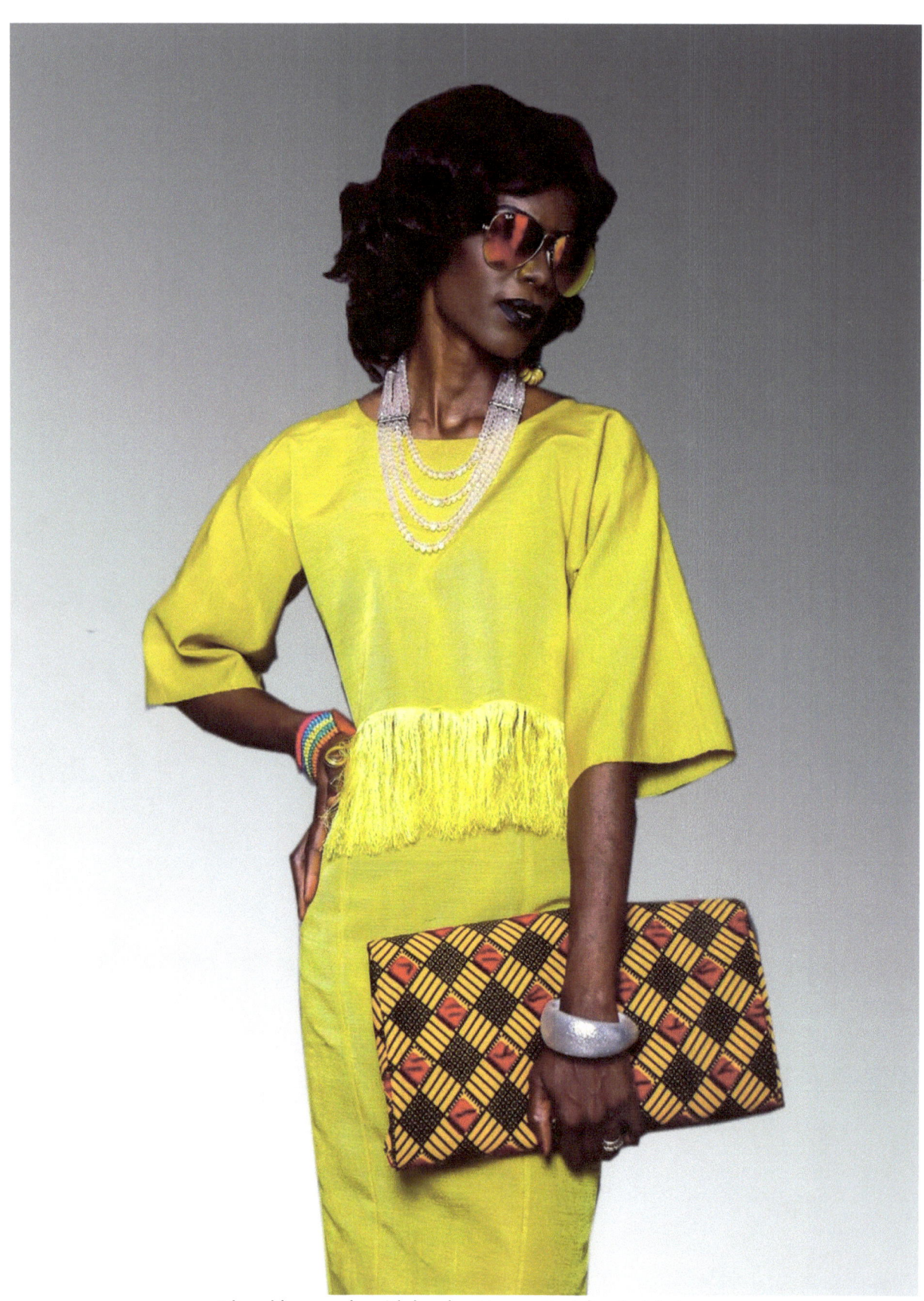

A hand bag made with local cotton material called Ankara

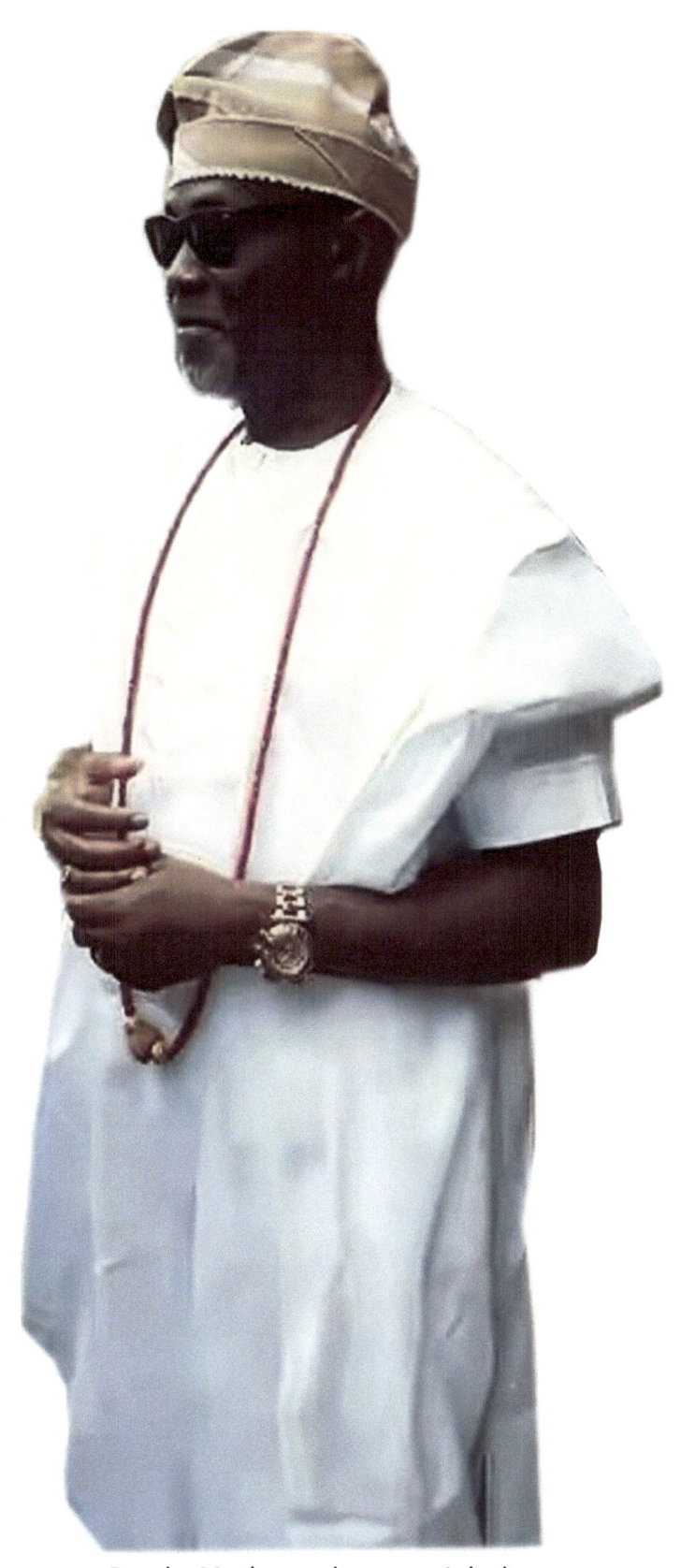

Popular Men's wear known as Agbada

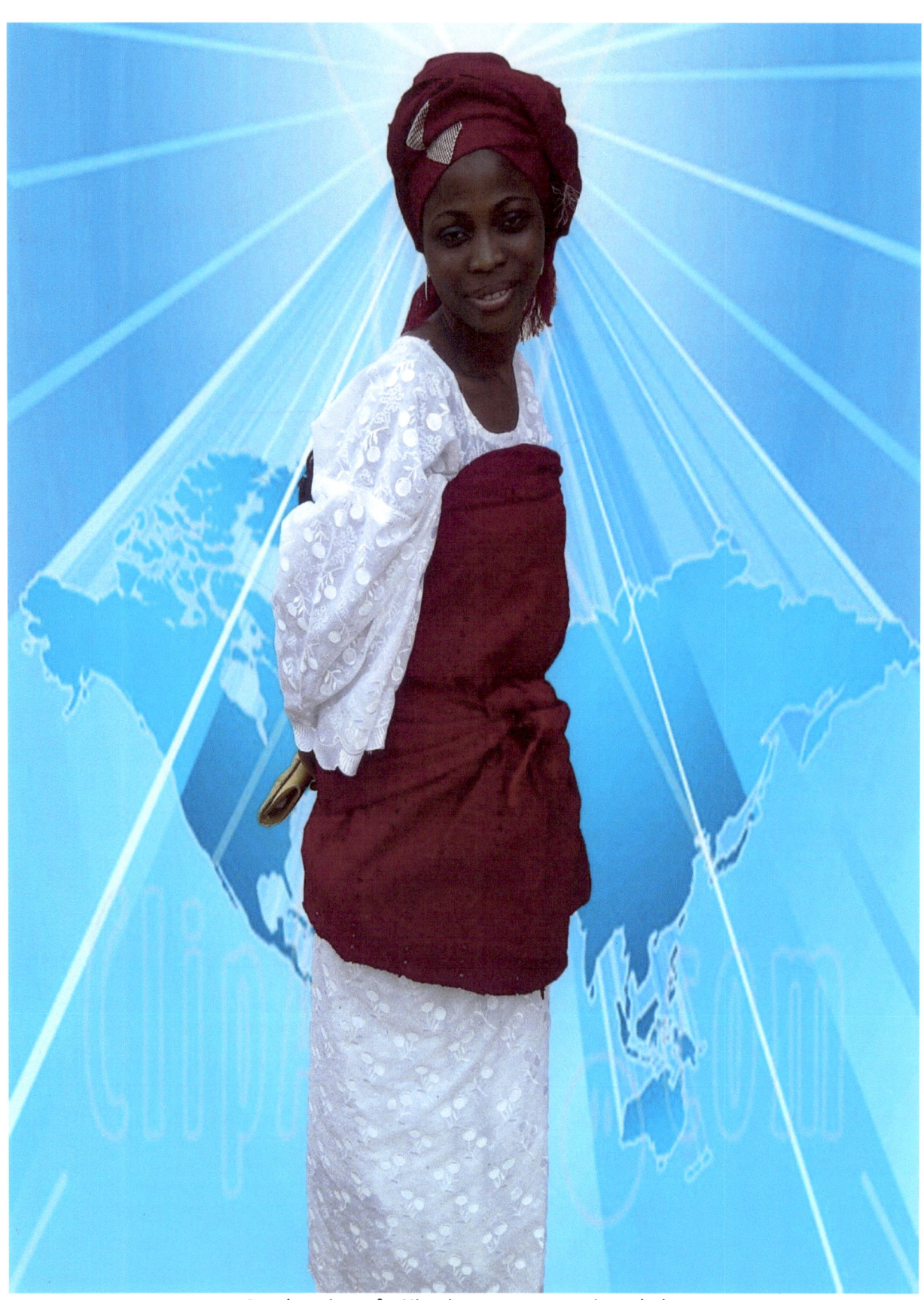

Another view of a Nigerian woman carrying a baby

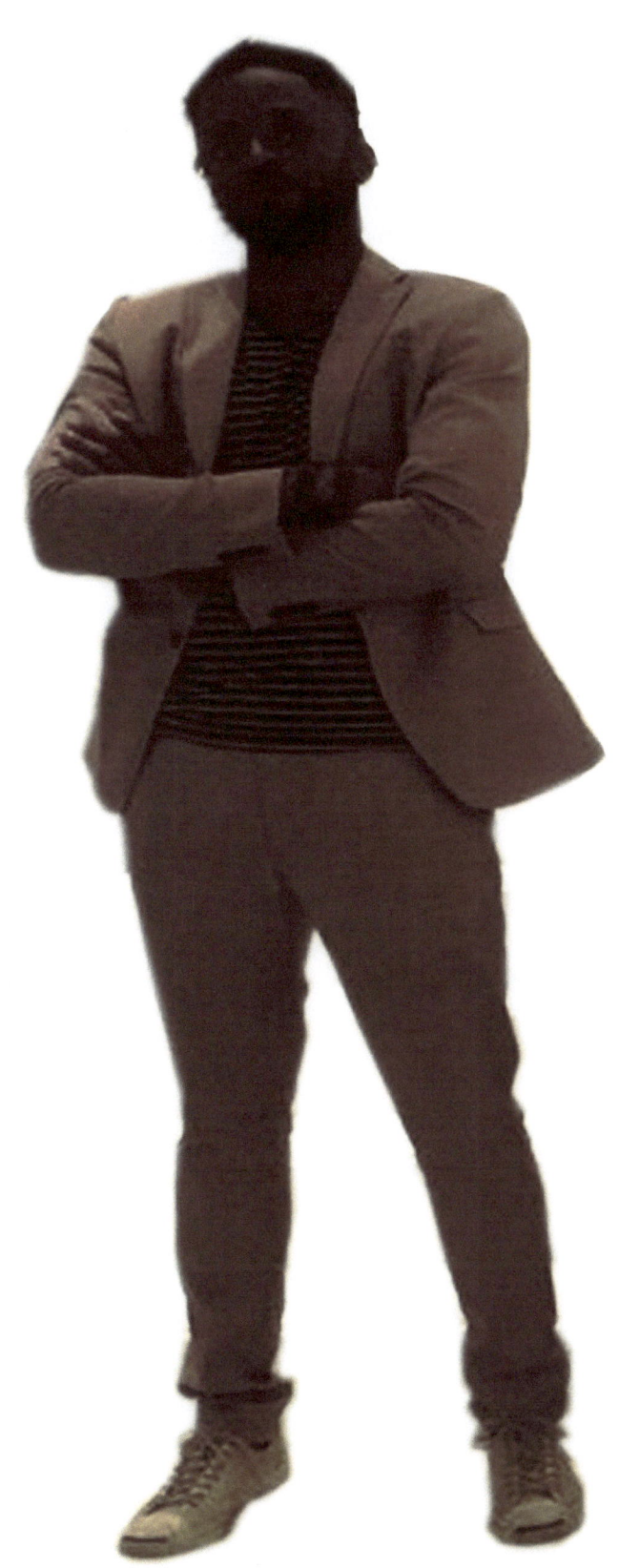

A Nigerian made suit

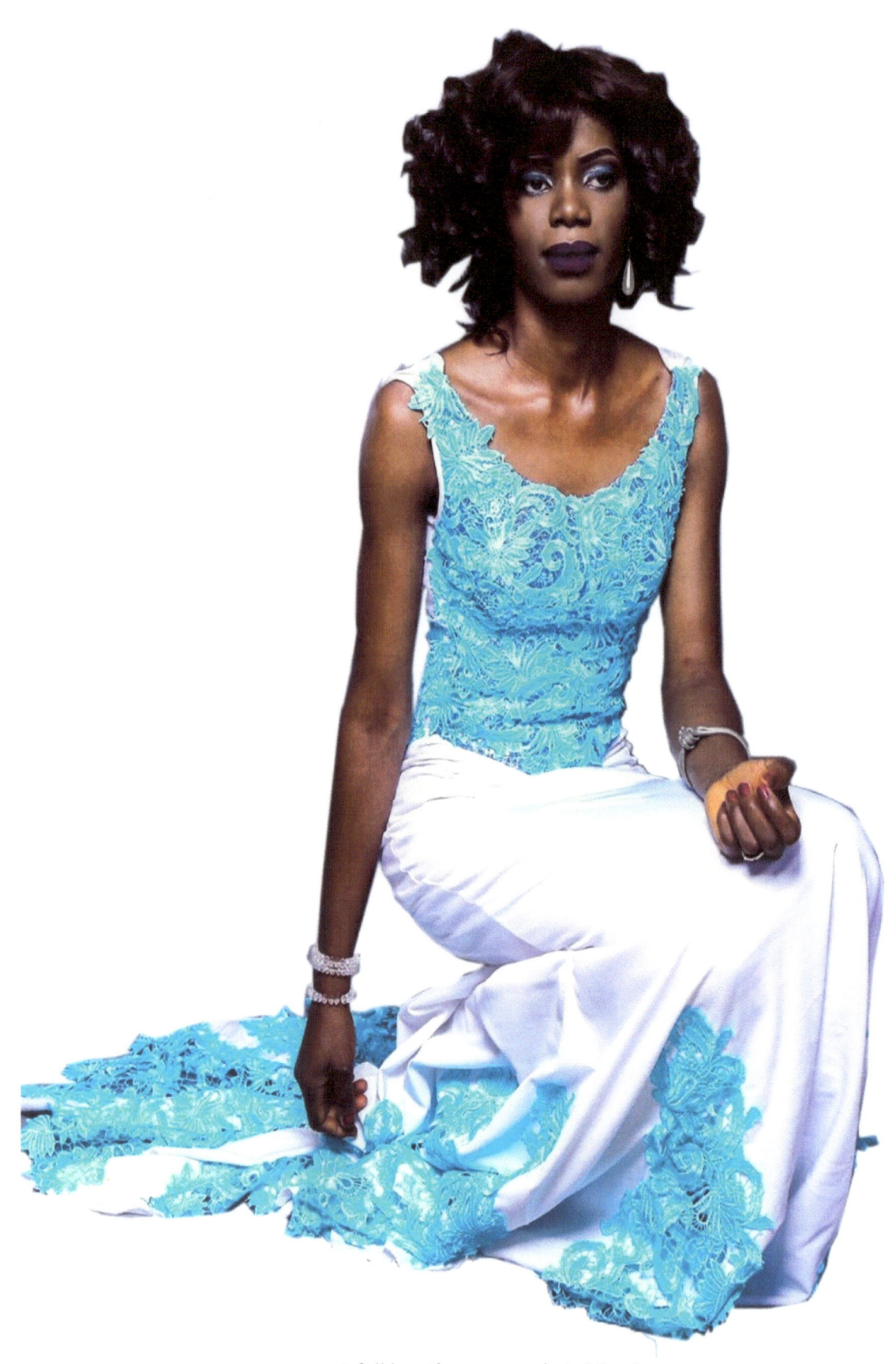

A full length gown made in Nigeria

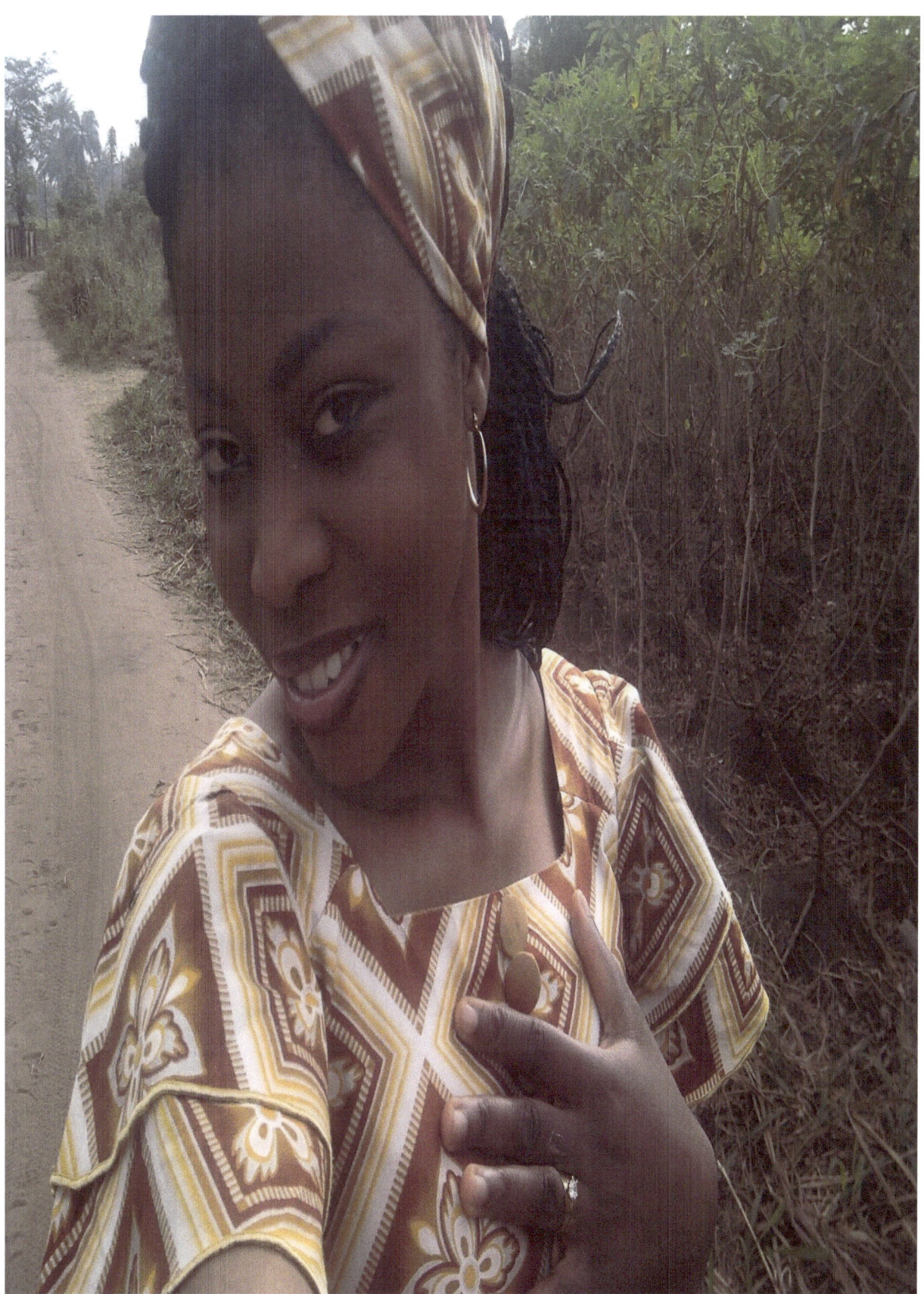

A skirt and blowse made with Ankara

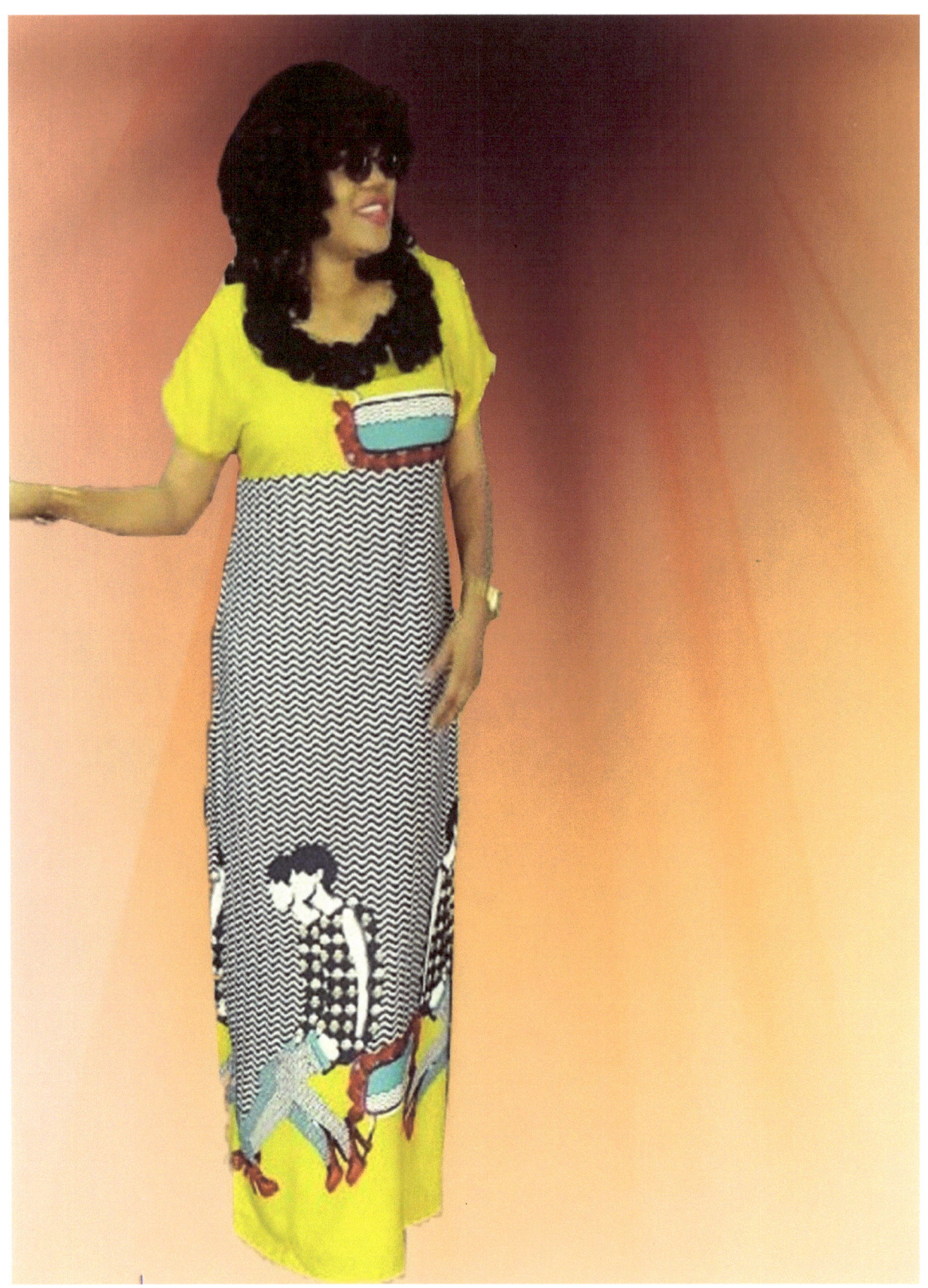

Nigerian made gown

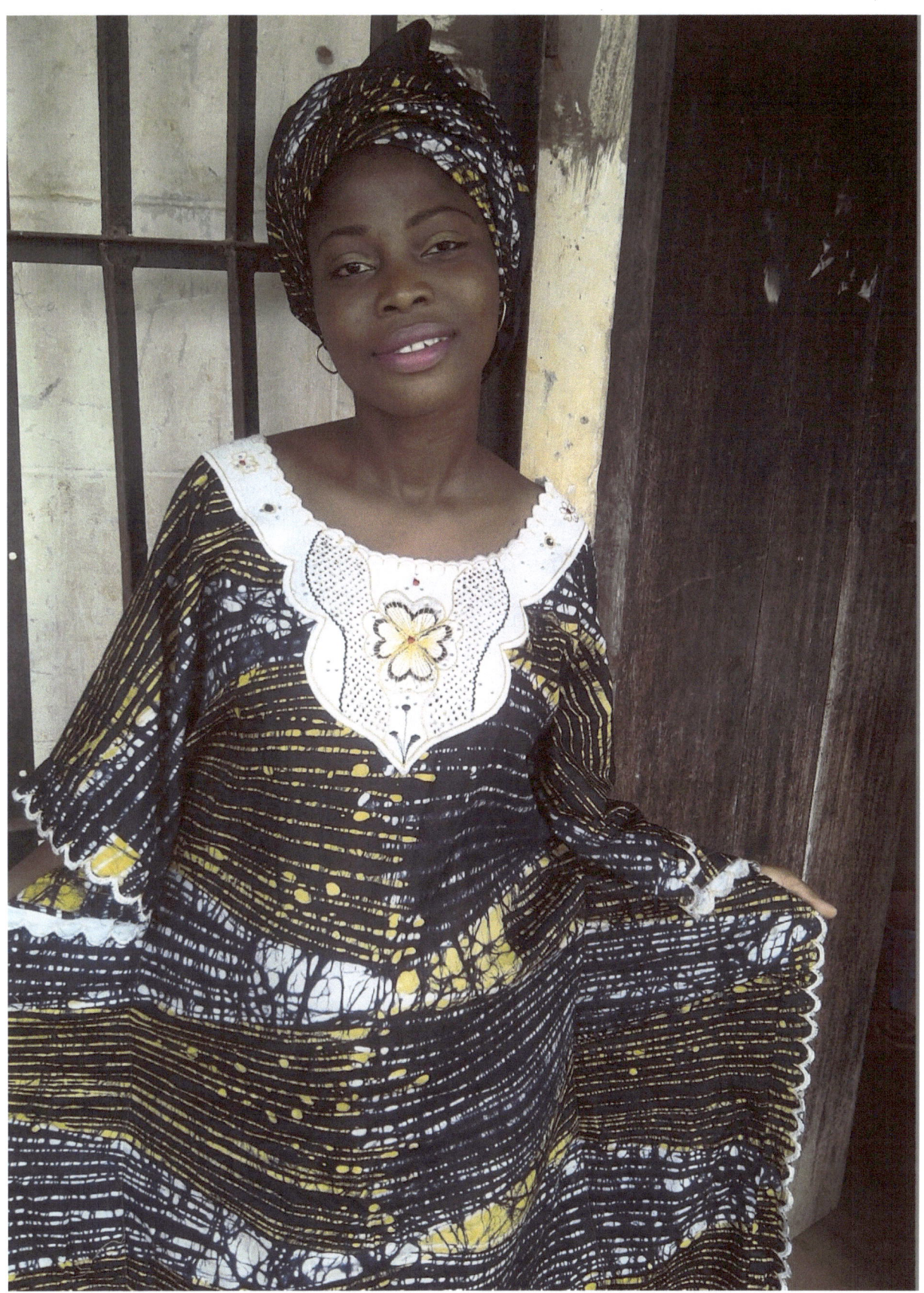

A gown made with a certain material called soaked in dyes and called Kampala

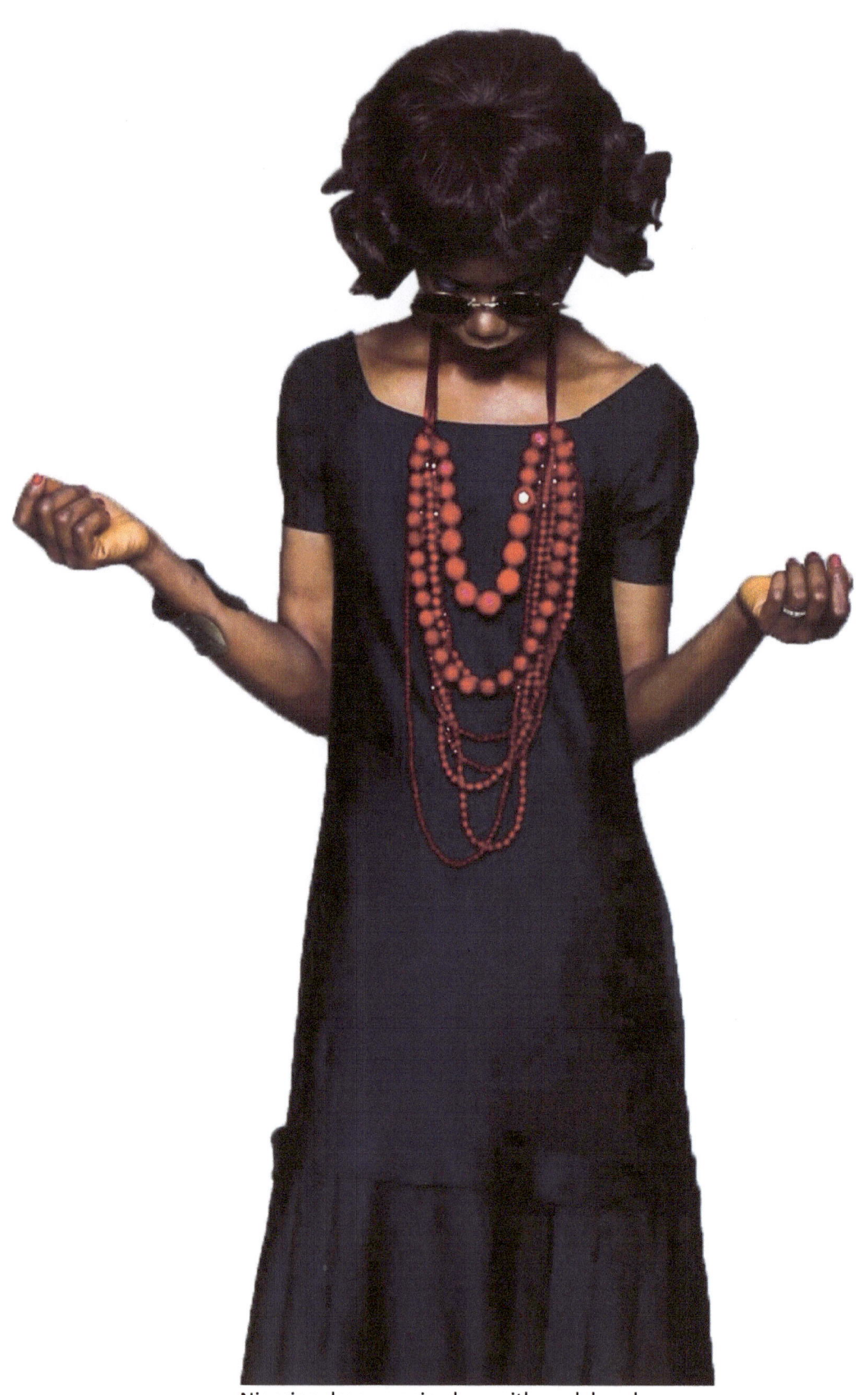
Nigerian dresses spiced up with neck beads

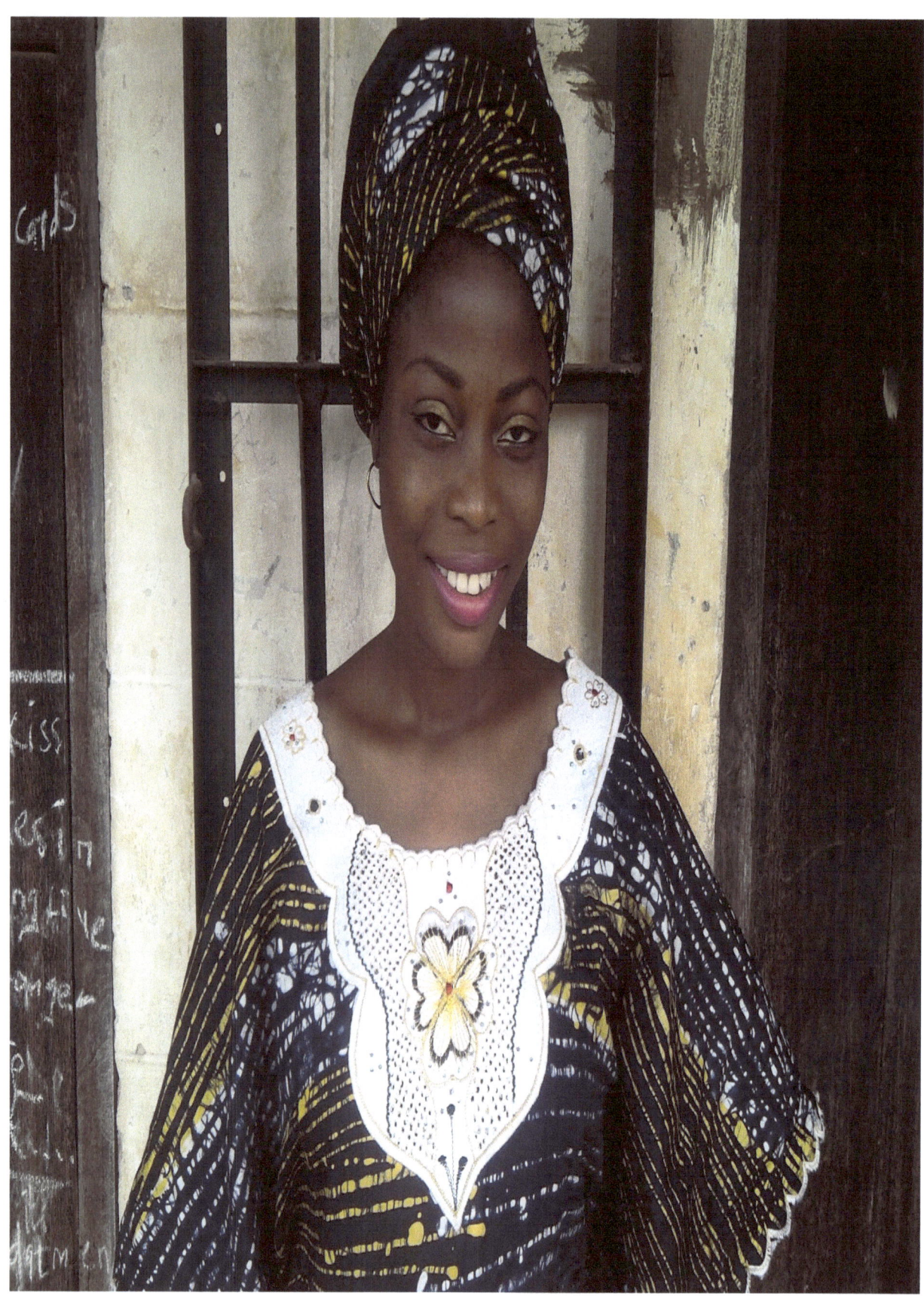

Another view of women's gown

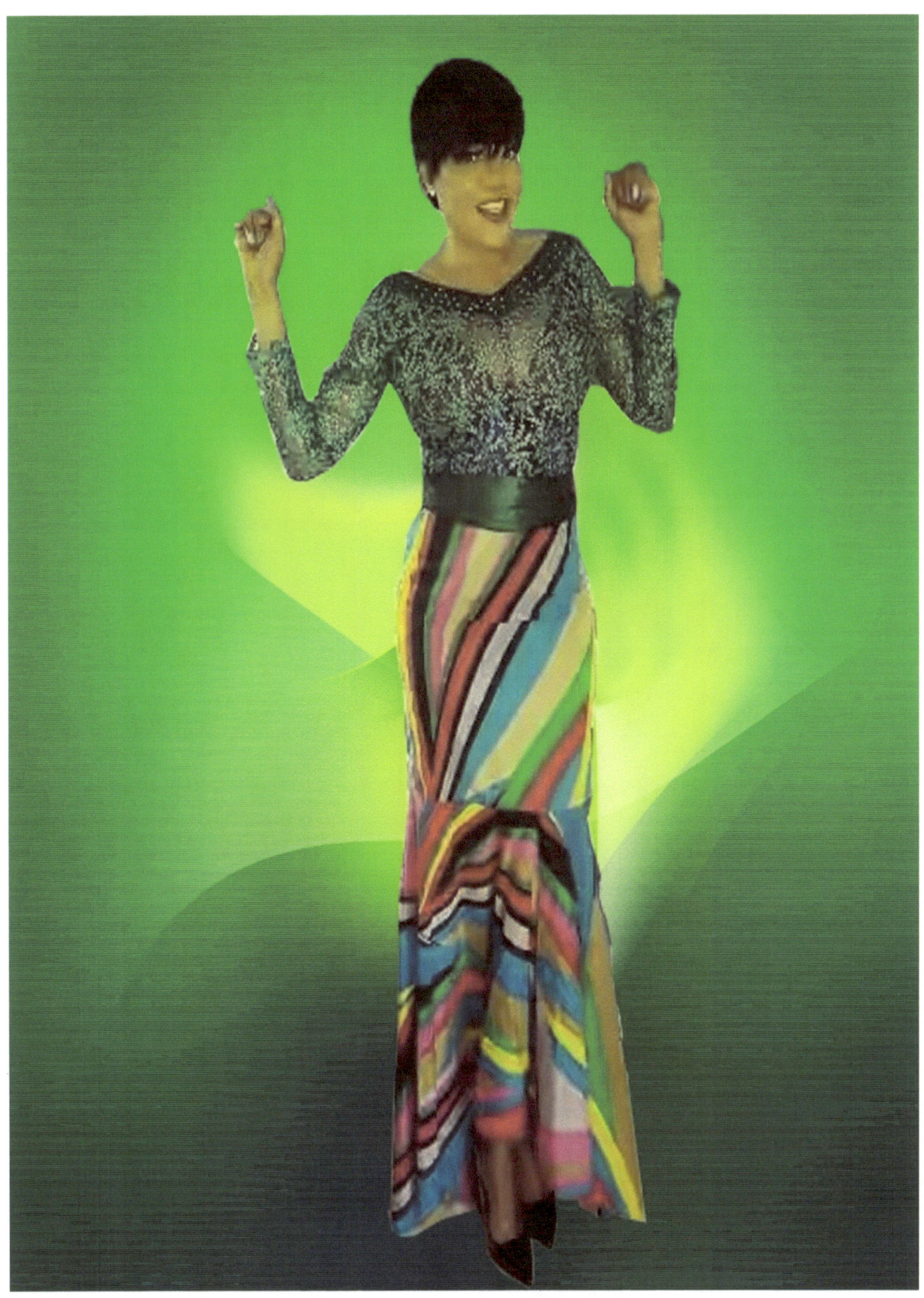

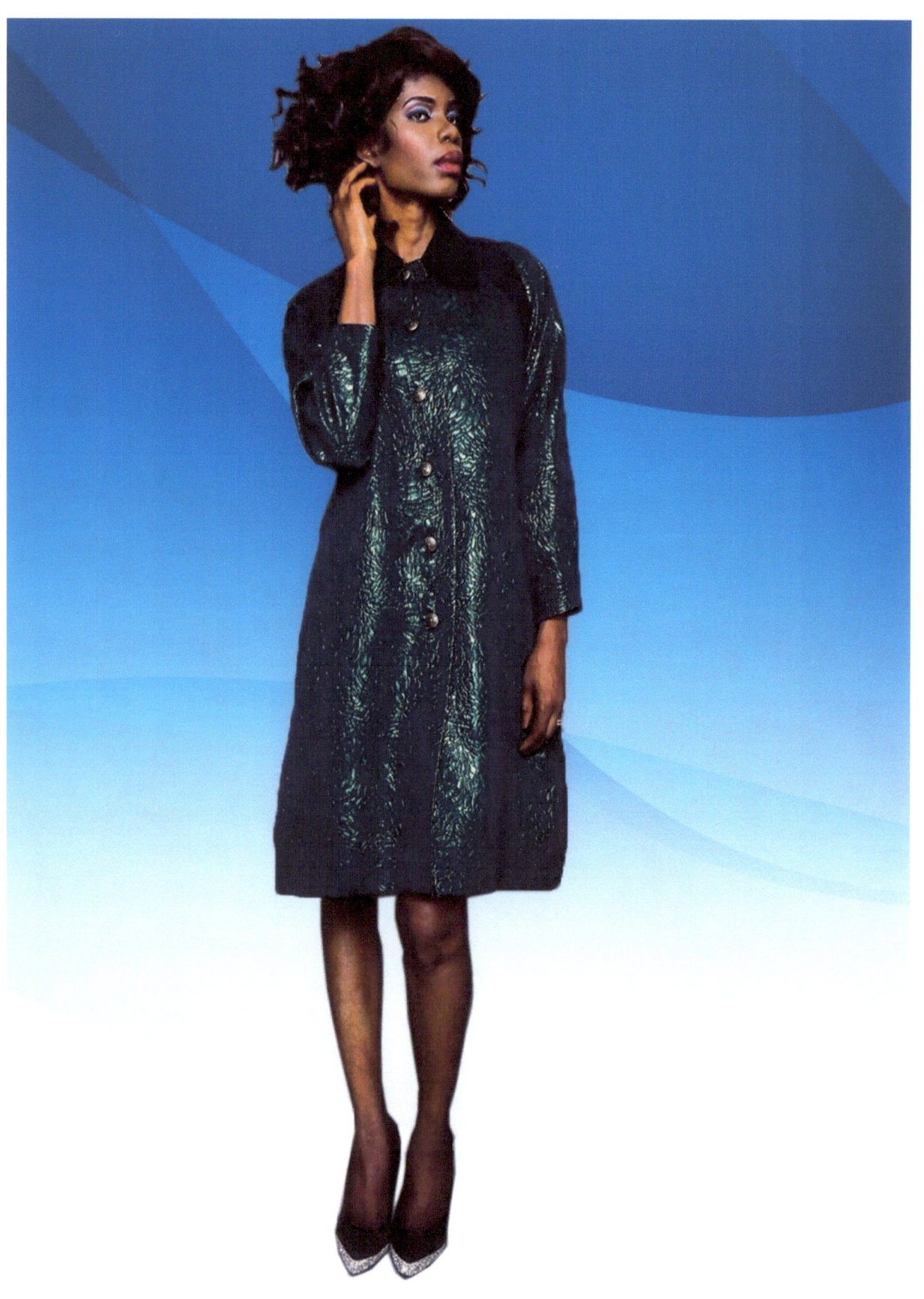

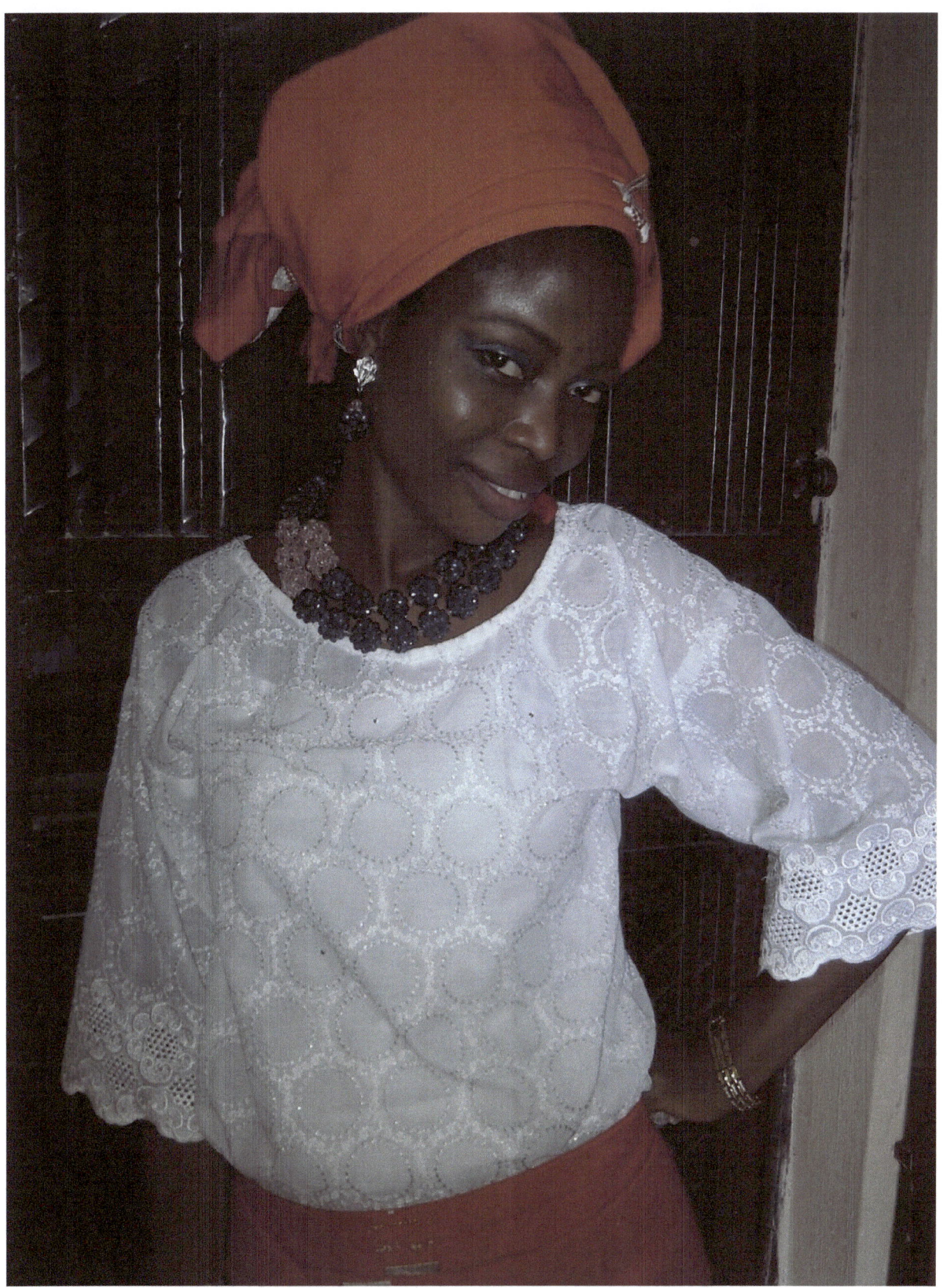

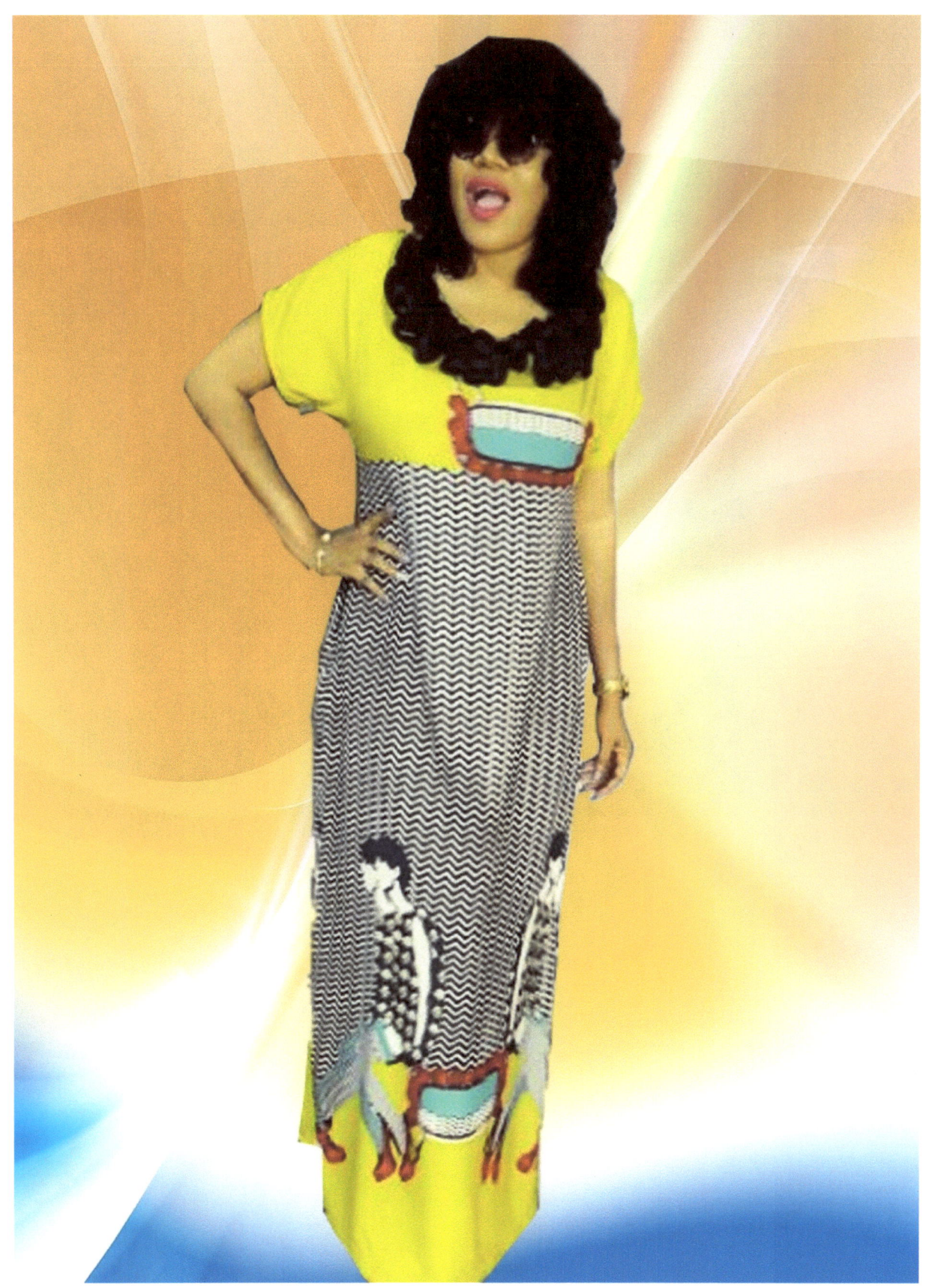

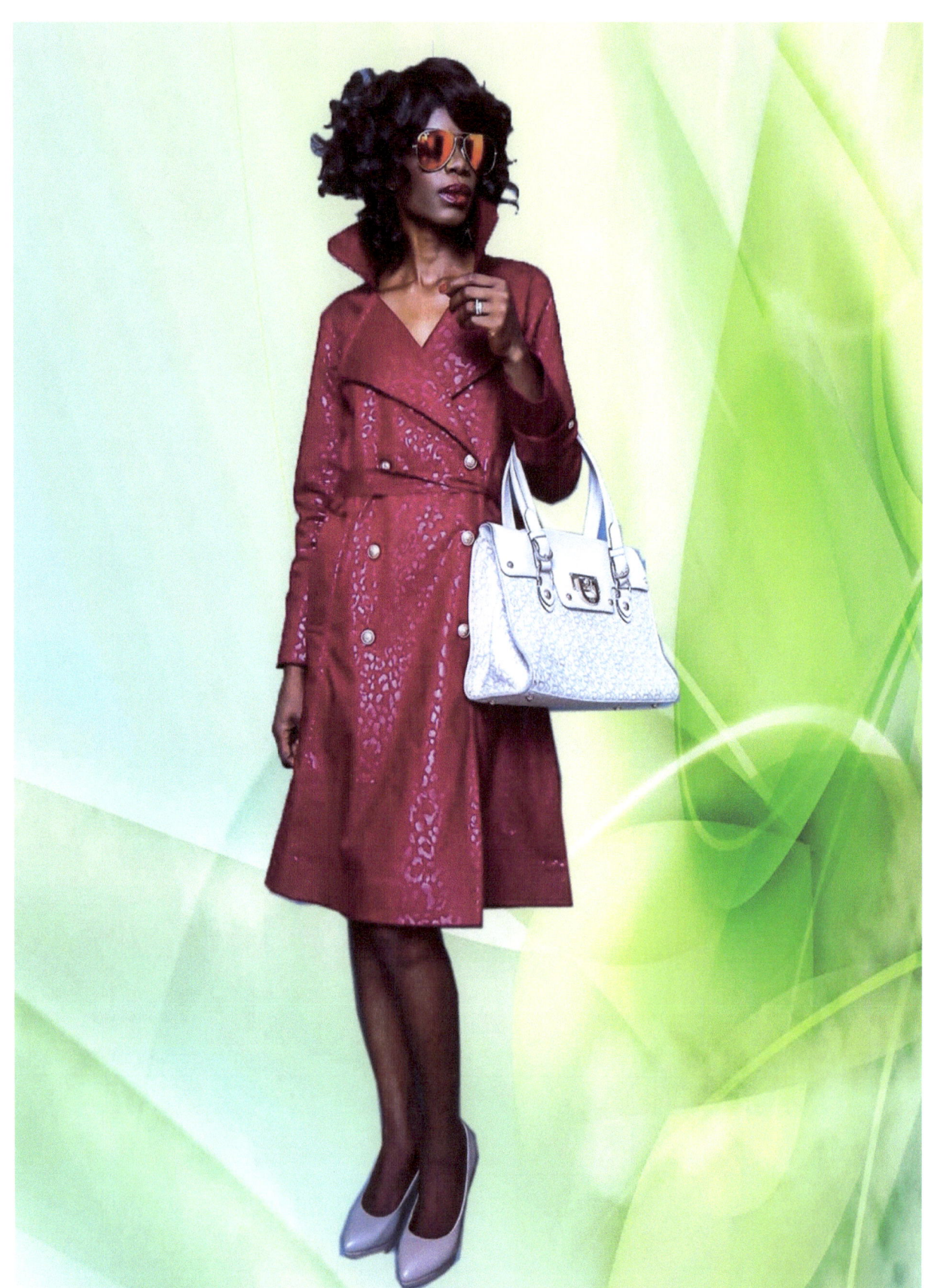

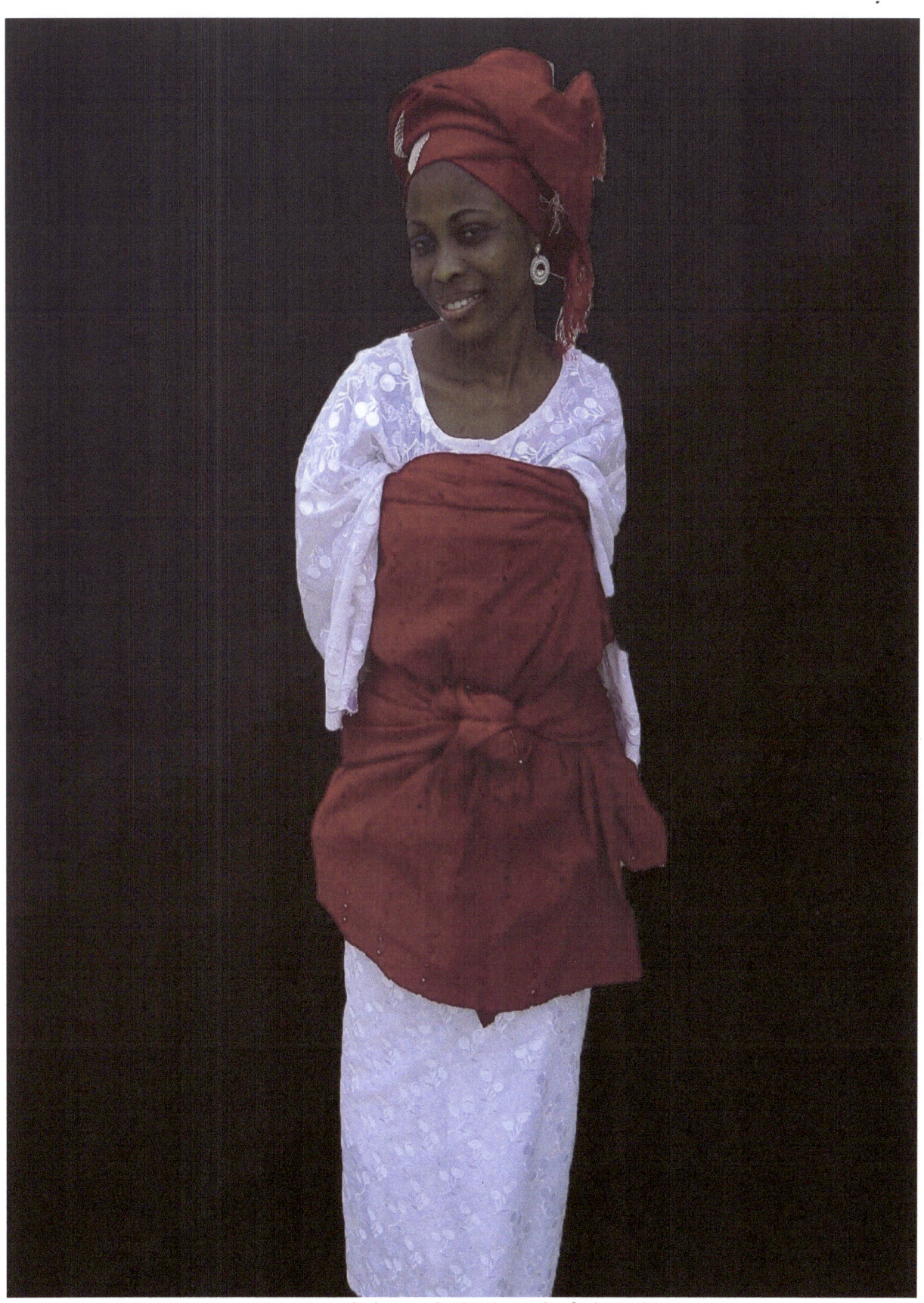
Carrying a baby on the back can be fashionable

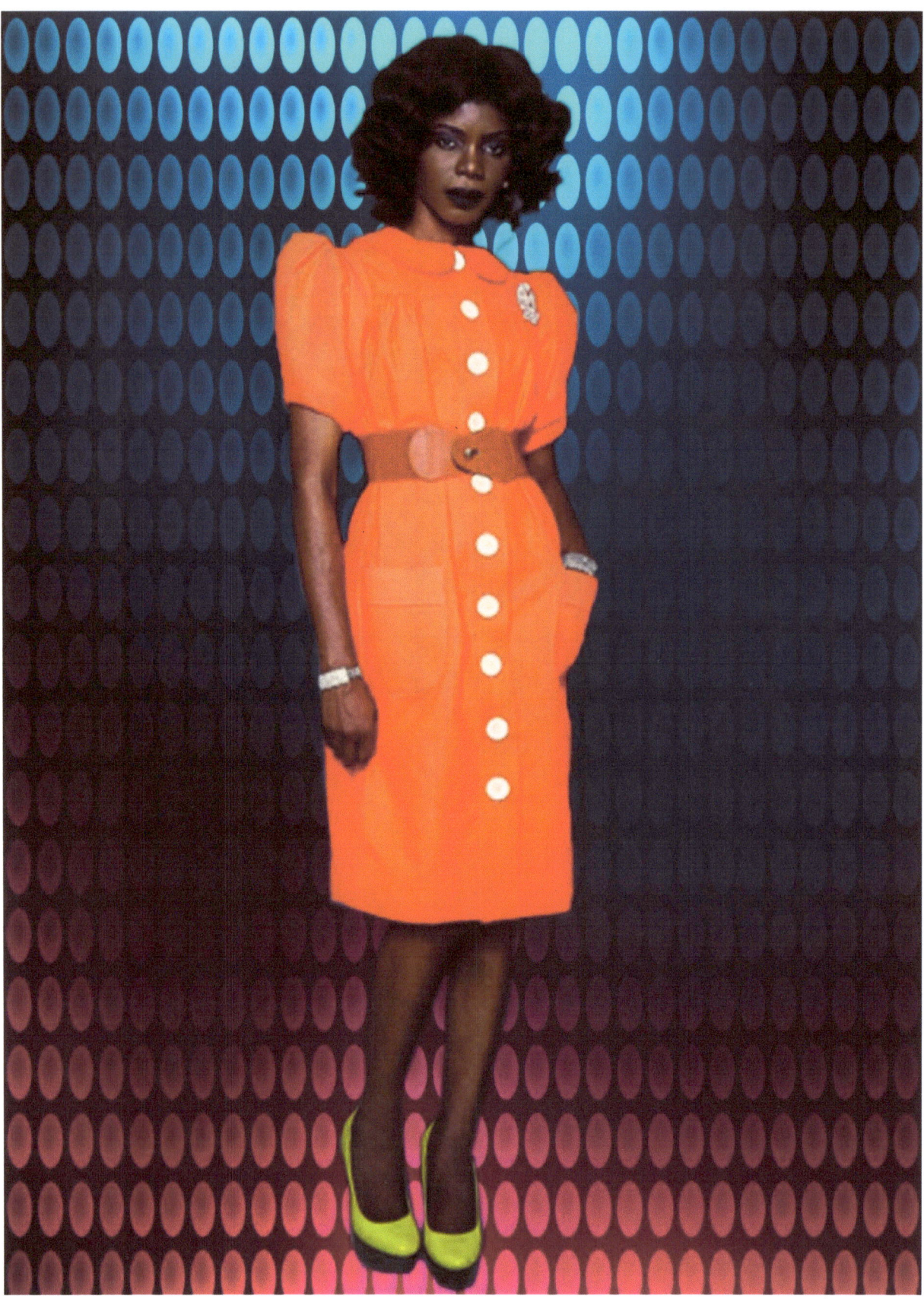

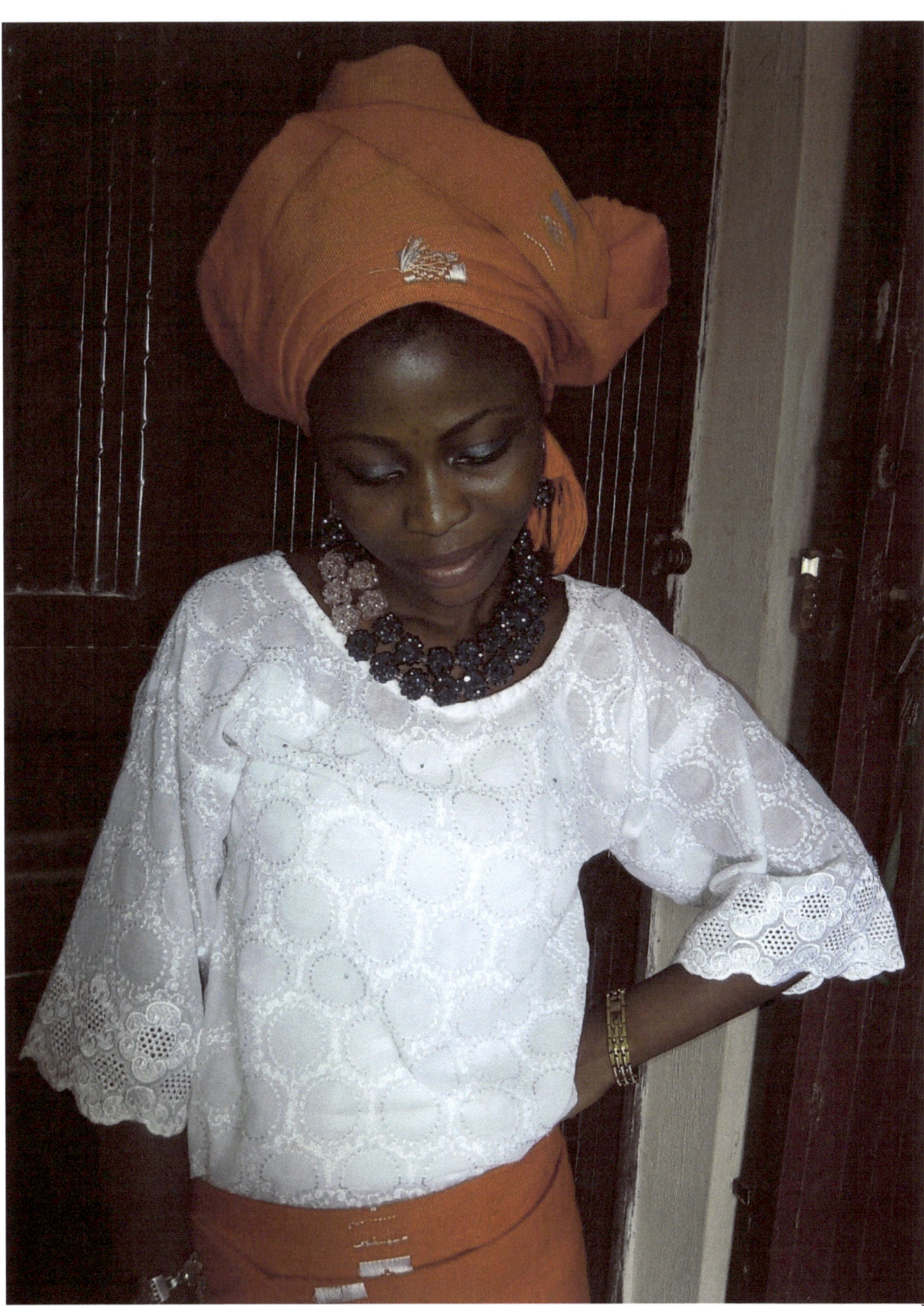

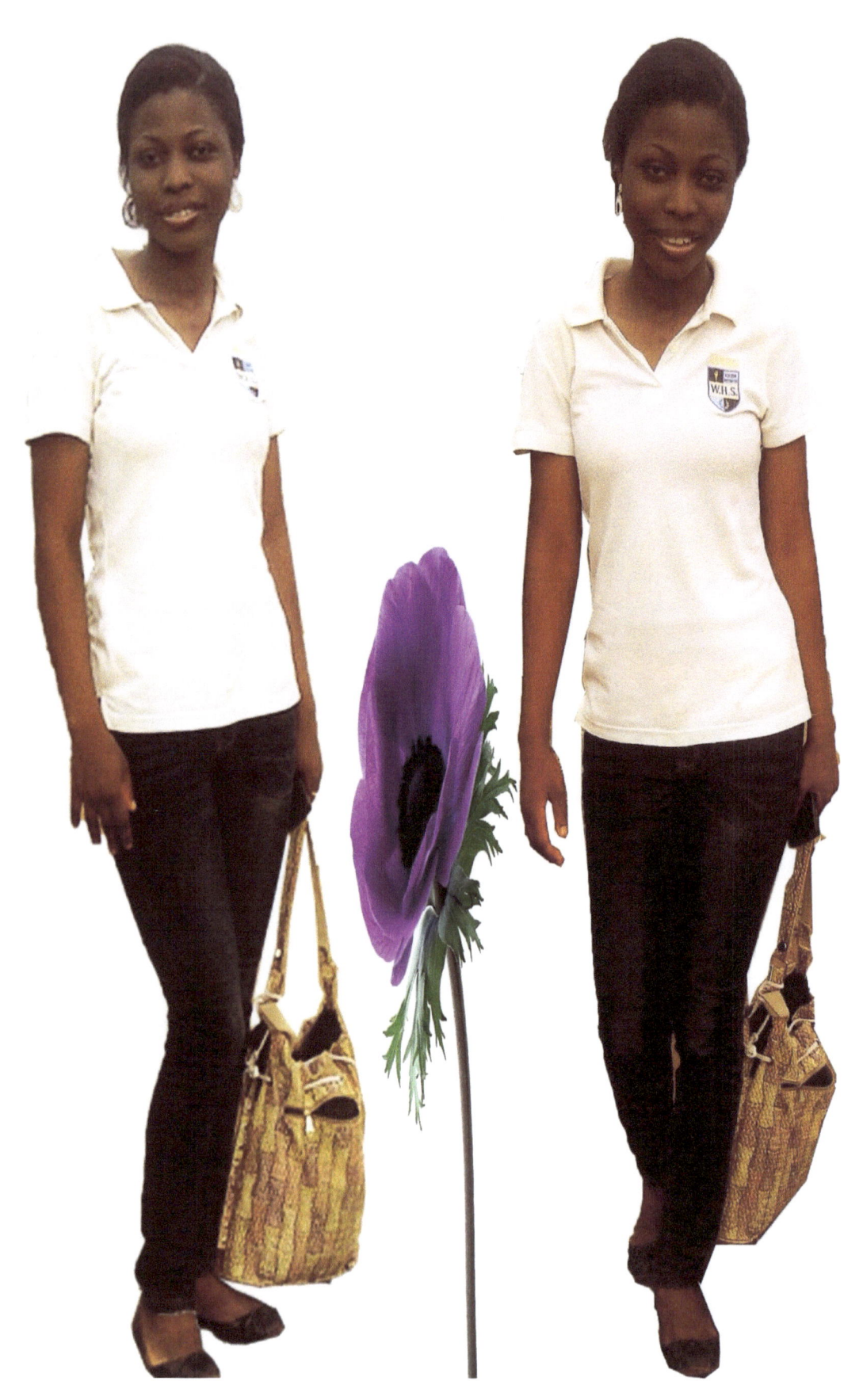

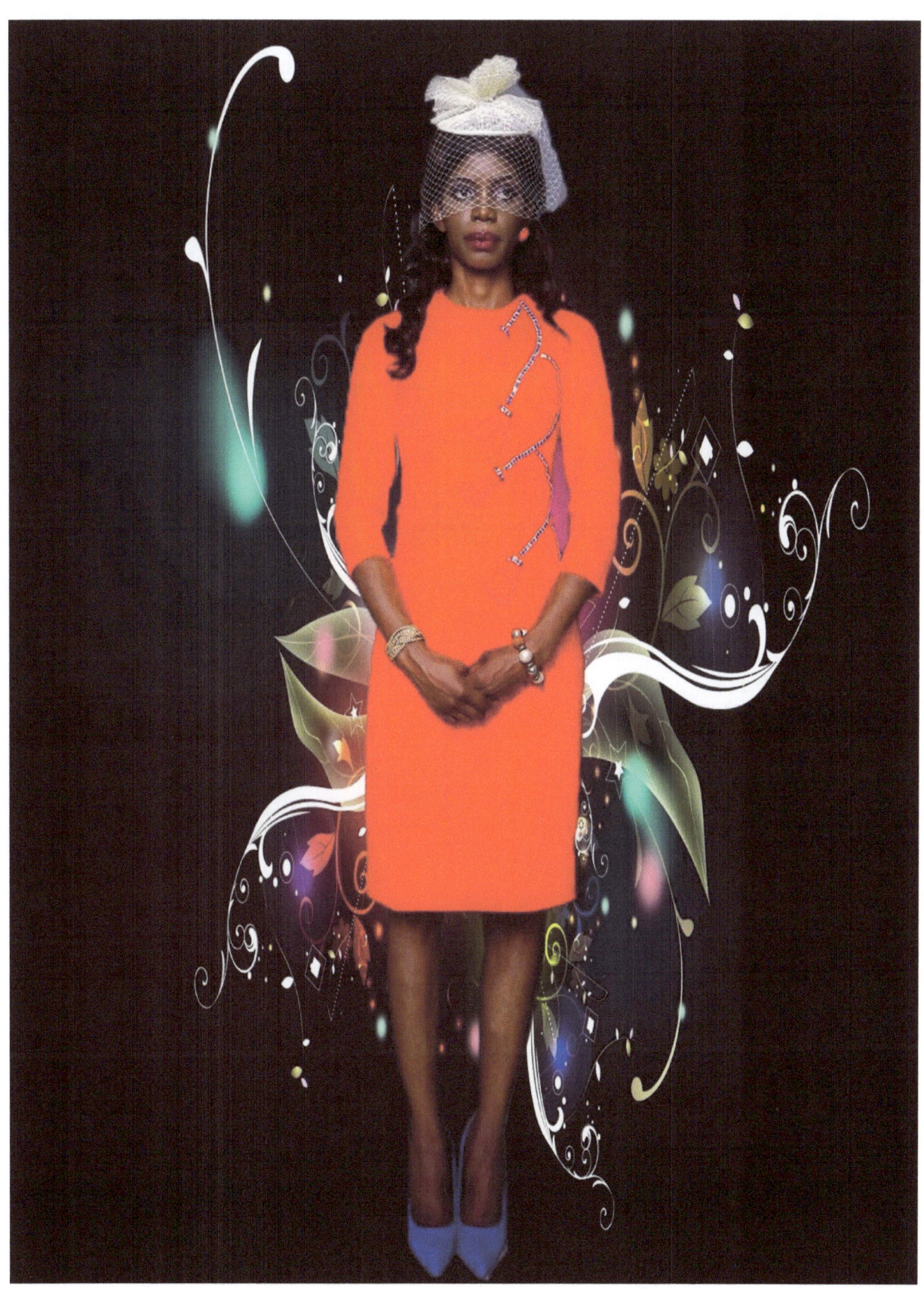

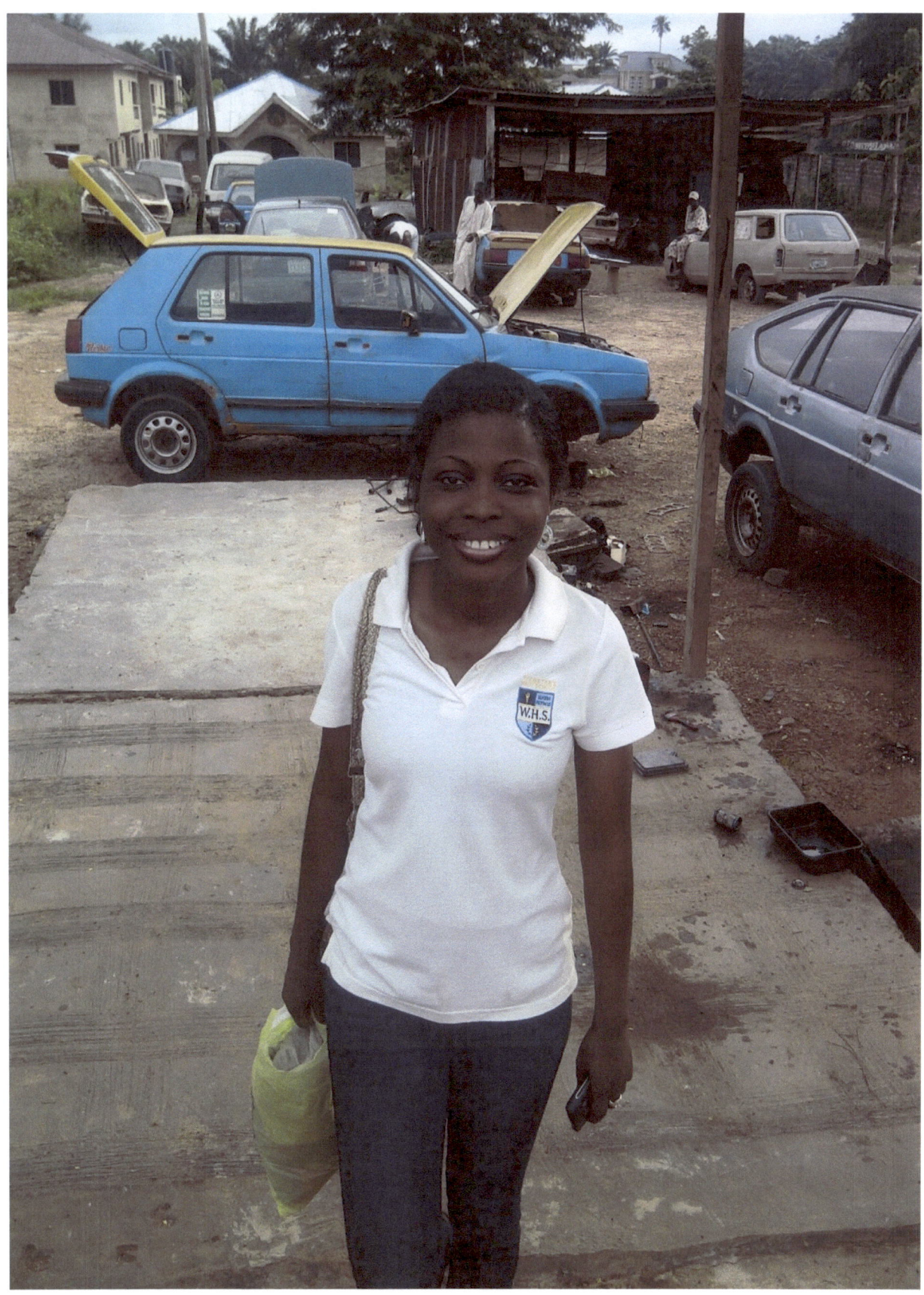

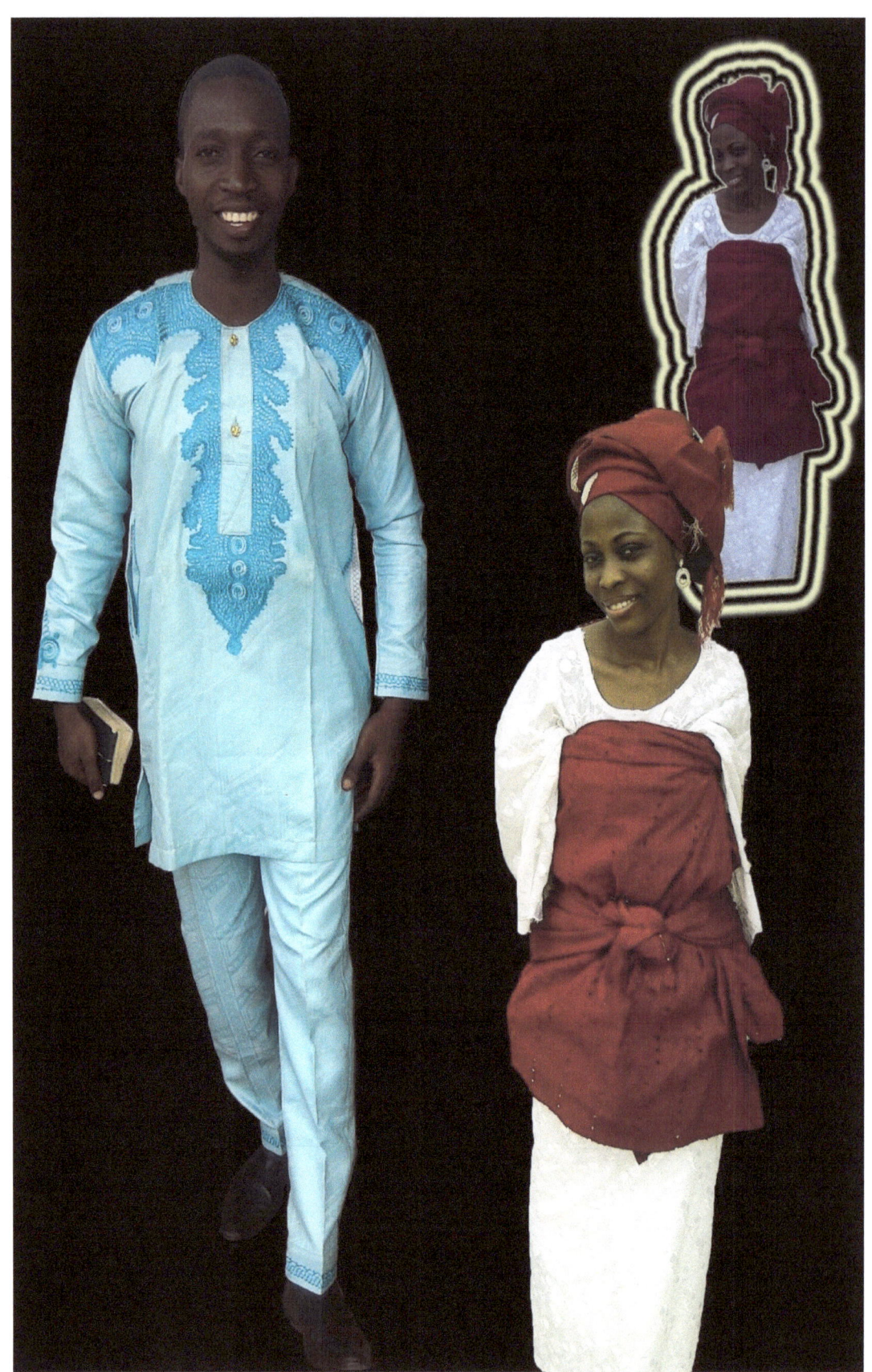

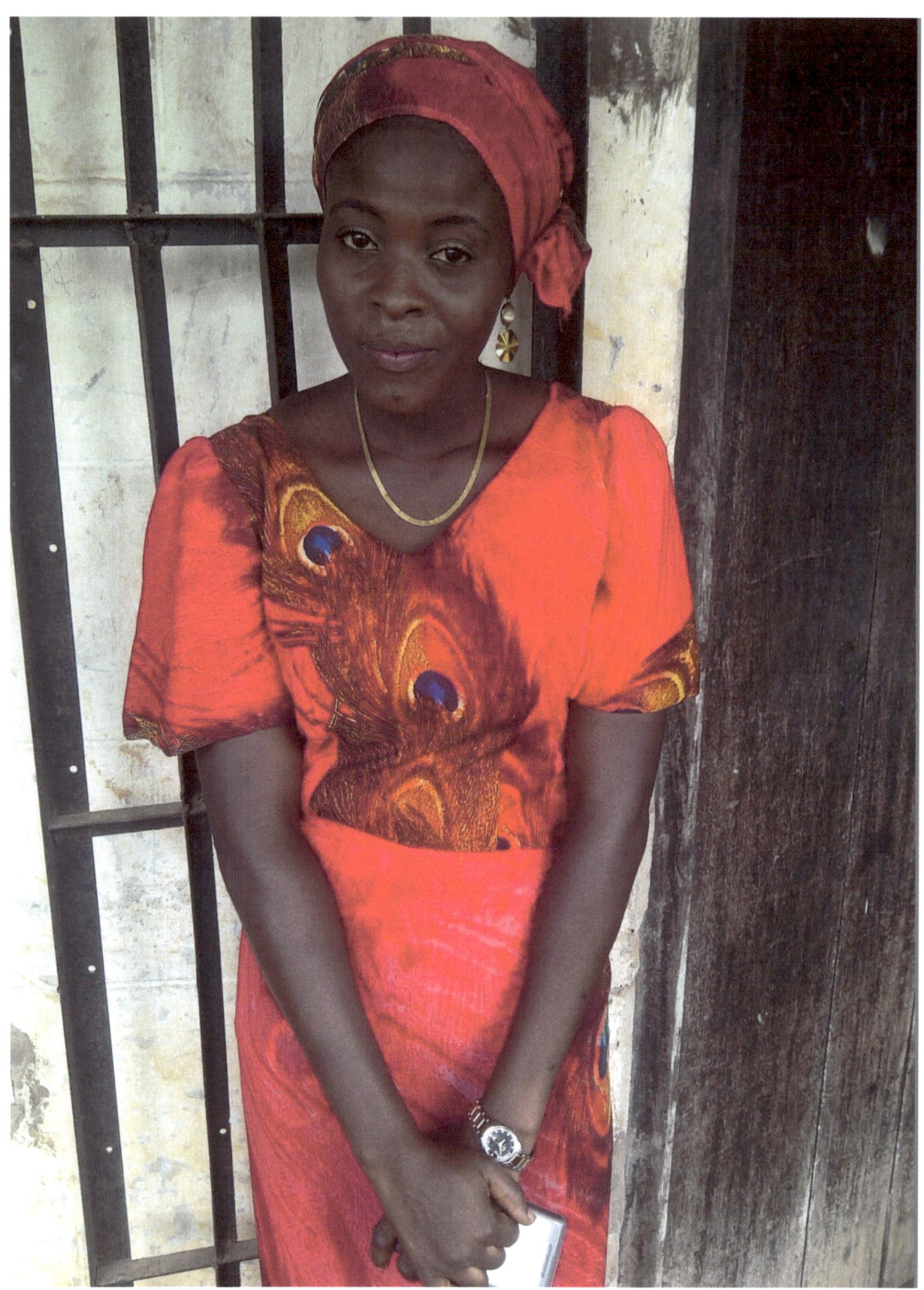